WATERCOLOR BASICS:
LIGHT

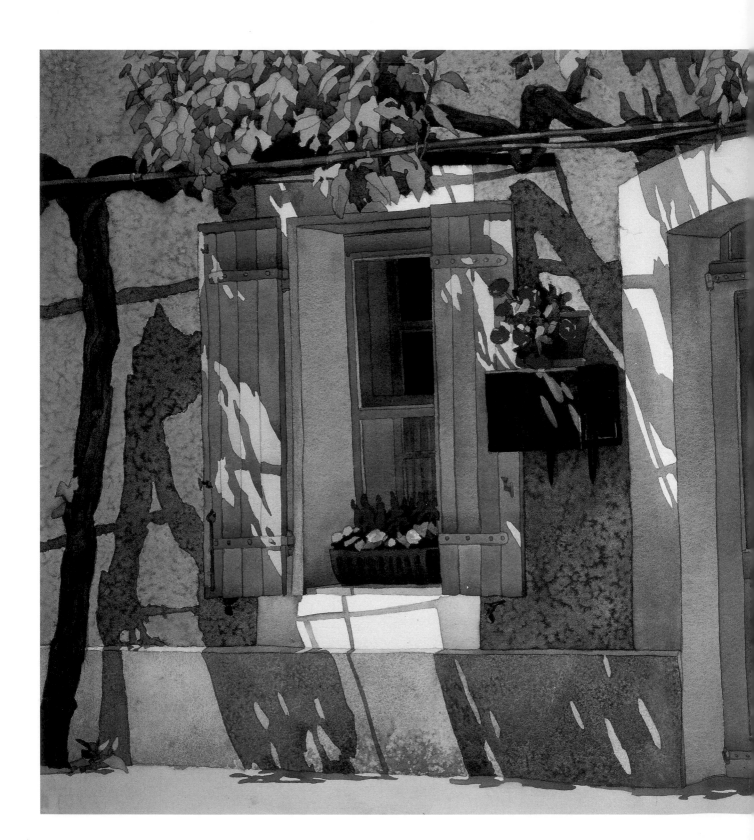

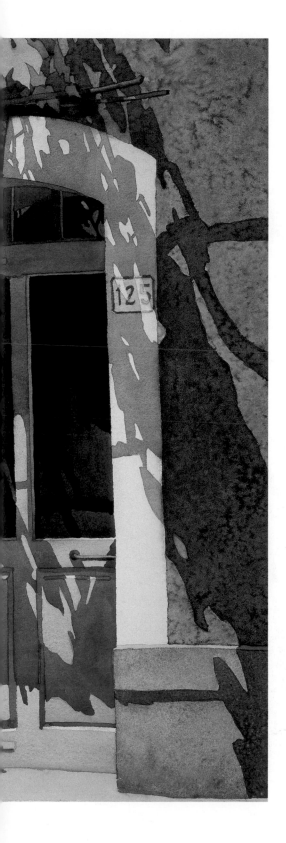

WATERCOLOR BASICS: LIGHT

JUDY MORRIS

NORTH LIGHT BOOKS
CINCINNATI, OHIO
www.nlbooks.com

ACKNOWLEDGMENTS

Without the total support from my husband, Tom, my art career would not have been possible. He did whatever needed to be done when I said "I can't now, honey. I'm painting." His love and logic guide my life. Thank you Sarah, my wonderful daughter, for "not talking to me until noon" so I could paint. Thank you even more for helping me with the computer when it wouldn't do what I wanted it to do! My love of watercolor started when my twin sister, Jacque Brown, and I took a summer workshop so we could have another excuse to be together. The love continues, both for watercolor and for Jacque. The time we spend together is sheer joy and I can even get her to paint once in a while! Thank you friends, especially Sam, who understands when I don't even have time to meet for lunch. Hugs to Elizabeth Ellingson and Kathy at Frodsham's, whose professional photography and advice got me past my "camera block"! Thank you, Rachel Wolf, for finding me and starting the whole process that ends up being a book. And finally, a very special thank you to Jennifer Lepore, my editor. I can just imagine what she thought when I submitted the first draft for chapter 1. She didn't tell me it was bad. Instead, she made a few suggestions and probably thought to herself "This is going to be a hard one." Because of her patience, professionalism and wisdom, I can share my enthusiasm for watercolor with you.

Watercolor Basics: Light. Copyright © 2000 by Judy Morris. Manufactured in China. All rights reserved. No part of this book may be reproduced in any form or by any electronic or mechanical means including information storage and retrieval systems without permission in writing from the publisher, except by a reviewer, who may quote brief passages in a review. Published by North Light Books, an imprint of F&W Publications, Inc., 1507 Dana Avenue, Cincinnati, Ohio 45207. (800) 289-0963. First edition.

Other fine North Light Books are available from your local bookstore, art supply store or direct from the publisher.

04 03 02 01 00 5 4 3 2 1

Library of Congress Cataloging-in-Publication Data

Morris, Judy.
 Watercolor basics. Light/Judy Morris.—1st ed.
 p. cm.—(Watercolor basics)
 Includes index.
 ISBN 0-89134-963-4 (pbk. : alk. paper)
 1. Watercolor painting—Technique. 2. Light in art. I. Title.
ND2420.M64 2000
751.42'2—dc21 99-056641

Edited by Jennifer Lepore
Cover designed by Wendy Dunning
Production coordinated by Emily Gross
Cover/page 2–3 art: *La Porte Bleu*, 29" × 21" (75cm × 53cm)
Page 6–7 art: *Dans Une Boite*, 29" × 21" (75cm × 53cm)
Pages 34, 35 and 88 include artwork copyrighted by and appearing with the permission of Jacque Brown, Judy Morris' twin sister.

DEDICATION

*This book is dedicated to Vi and A.J. Ayres, my parents,
whose last gift was the most precious of all.*

ABOUT THE AUTHOR

Judy Morris earned B.S. and M.S. degrees in art education from Southern Oregon College (now Southern Oregon University) in Ashland, Oregon. She taught art at South Medford High School for thirty years before retiring in 1996 to become a full-time professional watercolorist. In the last decade Morris has conducted painting workshops on location throughout the country and in Canada, Mexico, England, Switzerland and Italy. Her paintings have received more than forty national and regional awards and have been exhibited throughout the country. Her work hangs in public and private collections from California to New York, Canada to Mexico, and in Europe. She has been a member of the Watercolor Society of Oregon since 1980 and is a signature member of the National Watercolor Society, The Midwest Watercolor Society and the Northwest Watercolor Society. Her works are included in many books, including *Best of Watercolor* and *People in Watercolor* by Rockport Books, *Splash 4, Splash 5* and *Best of Flower Painting 2* by North Light Books, and in magazines including *Watercolor, Watercolor Highlights 2* and *The Artist's Magazine*. Morris has been selected for inclusion in the forthcoming twenty-first edition of *Who's Who of American Women* and *Who's Who in the World 2000*. She is represented by the Mockingbird Gallery in Bend, Oregon, the Hanson Howard Gallery in Ashland, Oregon, and RendonArt Collection, Inc., Denver, Colorado. Morris maintains her studio in Medford, Oregon. Visit her Web site at www.judymorris-art.com.

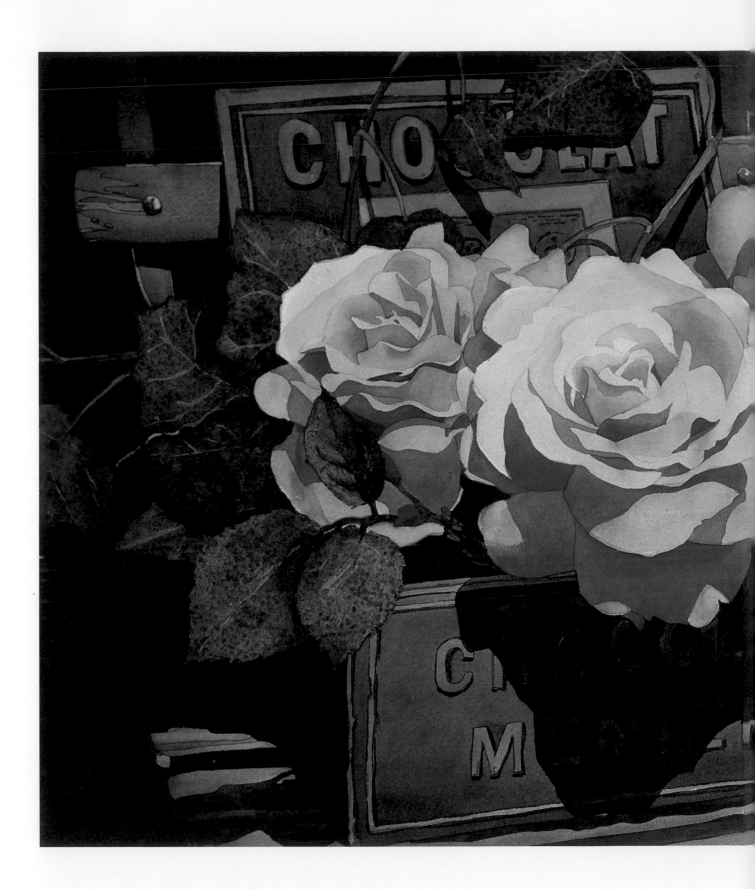

CONTENTS

INTRODUCTION

My affair with watercolor started when I needed one more studio class to finish my master's degree. A watercolor workshop was the most convenient class for my busy schedule. (Earlier attempts at the media convinced me to stick with oils and acrylics!) I struggled with unfamiliar techniques using paints, paper and brushes that seemed uncontrollable. I mixed a lot of "mud" and threw away stacks of failed paintings. The night before the final critique, bits and pieces I learned during the workshop came together in a small painting I felt was successful. I've been learning ever since!

Not wanting to forget anything I learned in the workshop, I sat at my computer and typed a list of "important things to remember" about watercolor. The list was two pages long, double spaced. As I continued taking workshops and painting I collected more information in a legal pad with tabs on the edge, breaking the information into categories such as "Materials, Techniques, Color, Value, Light, etc." When that was full I transferred the information to a three-ring binder with index sheets. When that was full I bought the largest binder I could find. The spine was 5" wide! Eventually it wasn't big enough and I asked my husband to build a special shelf in my studio that would hold the seventeen three-ring binders I currently have for "Materials, Techniques, Color, Value, Light, etc." I can't imagine what is next!

My passion for watercolor grew with my notebooks. By painting a lot I tested techniques, learned to use color and found solutions to watercolor problems. I also discovered the element that made painting in watercolor so intriguing for me. It was light! I loved light! I searched for light! I invented light! I focused on light! My "light" notebook filled the quickest.

I share my obsession with painting light in this book. I show you the tools and materials that work best, how to see light, how to "catch" light and how to attract attention with light. You will learn simple painting techniques that simulate the effects of light falling on and across subjects. I discuss the different kinds of light. You will learn when to keep light subtle and when to exaggerate it. You will understand why light is an important element in every painting. Use this information to make catching light a joy!

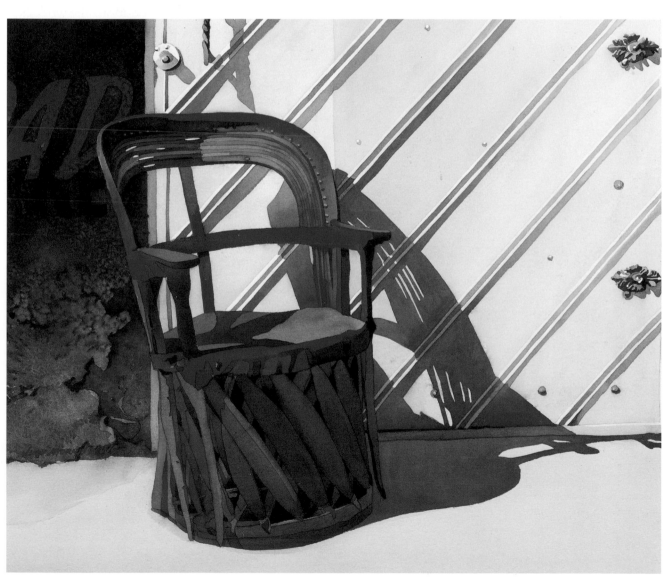

La Silla Roja
21" × 25" (53cm × 64cm)

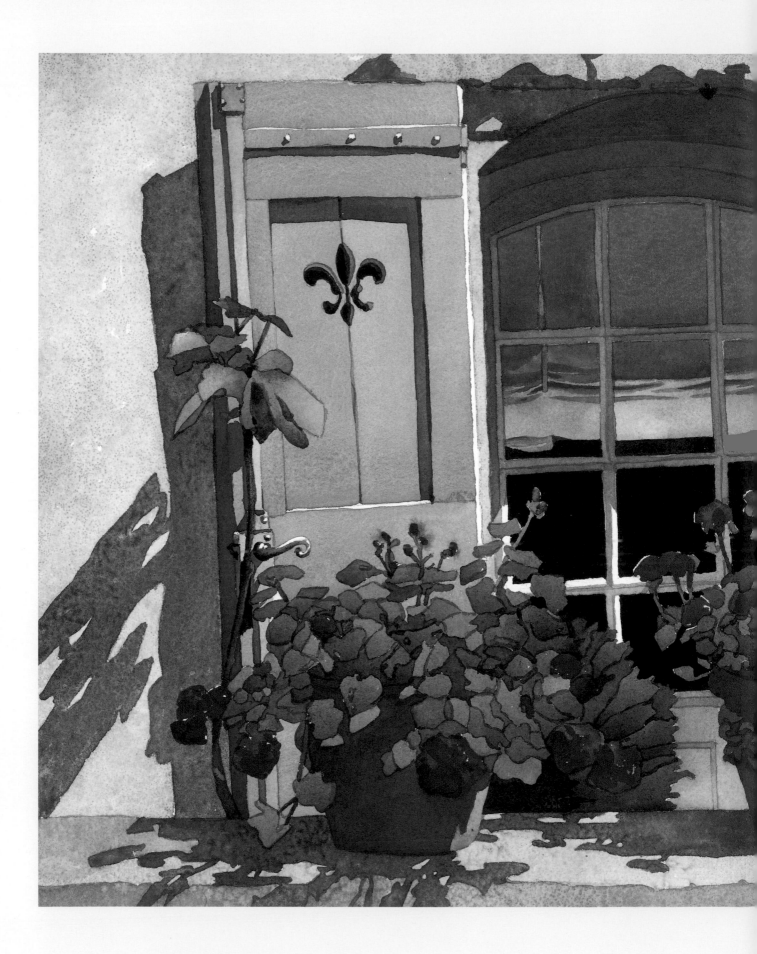

GETTING STARTED

I've always loved art supplies! Pencils, paper and paints of all kinds were my favorite Christmas and birthday presents. As a child, a pad of paper and a box of crayons could keep me occupied for hours. Now, as a watercolor artist, my favorite place in an art supply store is the watercolor section.

It's hard to shop for supplies when you want one of everything. There's a wonderful variety of watercolor tools, equipment and materials available that can make painting easier and more fun. But at first glance it seems confusing because there are hundreds of brush choices, many kinds of paper and literally thousands of colors of paint.

You don't need to buy them all! You can make beautiful watercolors with a minimal amount of supplies. The more you paint, the easier it will be for you to discover which painting supplies are for you. Start with the basic supplies. Later, you may add masking fluid, watercolor pencils, sponges, stencil knives or ink pens to your arsenal. You may find salt, rubbing alcohol, bleach or soap techniques a necessity. You may love the effect of combining gouache or acrylics with your transparent watercolors. The fun is in the discovering.

Colors of Provence
10" × 18" (26cm × 46cm)

Materials

Pencils

Different pencils have different purposes. A soft graphite pencil, such as a 6B, is good for doing thumbnails and value sketches. The harder, lighter HB or no. 2 pencil works well when transferring drawings to watercolor paper. These middle-of-the-scale pencils do not smear on watercolor paper, and the lines they create are dark enough to show through several layers of paint. Do not use a very hard graphite pencil on any watercolor paper. The line it creates is so light you may be tempted to press too hard to make a darker line—and you will actually create a dent in the surface of the paper. That dent will collect pigment when the paint is applied, creating a dark line.

Pens

You can use black ink pens to draw the preliminary lines for your paintings. The pens should be permanent if they're used on paintings that will be framed, displayed and, hopefully, sold. Use a pen with a light-fast, permanent, pigment-based ink, such as a Sanford Sharpie or a Staedtler pigment liner, for work that will be exposed to light. Be careful not to buy pens that bear the label "India ink" in quotation marks. The quotation marks on the label mean it is like India ink but is not permanent.

Erasers

I never like to erase on good watercolor paper. Erasing changes the surface of the paper, causing pigment to collect in the erased area and a dark spot to appear when paint is applied. What about mistakes? When you need to erase use a soft white eraser, never a pink one! (The paper is not pink!) Try to keep your erasures to a minimum by doing your drawing on inexpensive butcher paper. After you're satisfied with the drawing, use a lightbox to transfer your preliminary drawing to the watercolor paper.

Using a Lightbox

You can buy commercial lightboxes in a variety of sizes and price ranges. Check your local art supply store to see what's available. Or, you may improvise by using your dining room table, a piece of white Plexiglas (white diffuses the light better than clear), and a table lamp! Separate the table as if you're going to add an extension leaf. Place the white Plexiglas on top of the table over the separated section. Put the table lamp on the floor under the Plexiglas. Turn on the light and you've created a perfect "lightbox"! If you're using 300-lb. (640gsm) paper you may have to wait until dark and turn off the other room lights to clearly see your drawing shine through the watercolor paper.

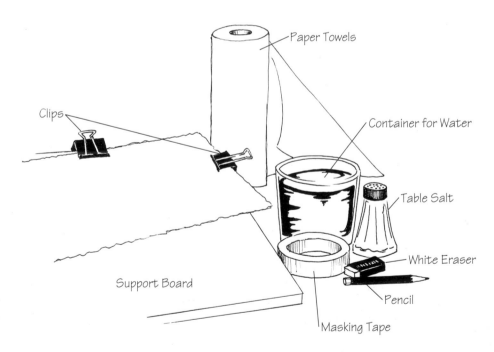

Basic Watercolor Materials

Watercolors can be created with a minimum amount of supplies. Beyond brushes, paint and paper you will need a pencil and white eraser for your preliminary drawings, a container for clean water and a support board (plywood, Masonite or a thick foamcore board) for your watercolor paper. You can use clips or masking tape to attach your paper to the support. Keep paper towels handy for any mopping up that is necessary. A shaker full of table salt (used for creating textures) is a must for my painting style!

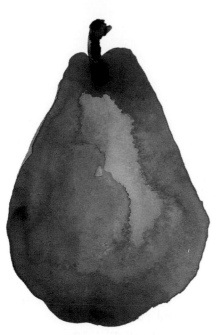
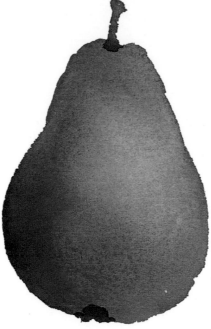
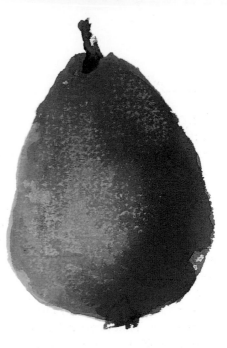

Hot-Press Paper

A hot-press paper surface is very smooth, causing paint to settle in surprising ways. You may get unexpected blooms (fan-shaped dark areas), uneven washes (color separations into light and dark areas) or puddles (paint drying darker on the edge than in the middle). The smooth, hard surface of hot-press paper allows you to move paint around and make adjustments easier than on the more textured cold-press or rough paper.

Cold-Press Paper

With cold-press paper, washes remain under control due to the slightly textured surface. There is enough texture on the surface of cold-press paper to use a technique called *dry-brush* (dragging an almost-dry brush lightly across the surface of the paper, letting paint stick to the "hills" and leaving the "valleys" white). Adjustments to cold-pressed paper are relatively easy to do, even when the paint has dried.

Rough Paper

Rough paper has a heavily textured surface. Pigments settle into the texture of the paper so that even a smooth wash gives the feeling of texture. If you want to emphasize surface texture in your painting, use a rough paper and granulating colors!

The pronounced "hills" and "valleys" also make it difficult to paint a smooth line or to adjust your painting if needed.

Paper

The surface of your paper reflects light through the transparent color put on top of it. This creates the luminosity typically associated with watercolor. A good-quality paper is essential to the painting process. All good-quality paper is acid free. The best is 100 percent cotton, sometimes referred to as "rag." Buy the best you can afford. It will be worth it.

Texture. Watercolor paper is available in a variety of surface textures. The trio of pears painted above shows the three most common paper surfaces: hot-press, cold-press and rough.

Thickness. Watercolor paper is sold by the pound. The weight is determined by actually weighing a ream (500 sheets) of 22" × 30" (56cm × 76cm) paper. If 500 sheets weigh 70 pounds (150gsm) the paper is quite thin. The higher the weight, the thicker the paper: 300-lb. (640gsm) paper is very thick compared to 70-lb. (150gsm) paper.

Thinner paper buckles more when wet, requiring stretching before it is used. Paper made with synthetic materials doesn't warp or buckle as much, but it is less absorbent. Heavier paper is usually more expensive.

Sizing. Sizing is an animal gelatin that is either added to the paper pulp before the paper is formed (internal sizing) or applied to the surface of a sheet of paper (surface sizing). Sizing adds strength. The more sizing a paper has, the less absorbent it will be. A paper with lots of sizing permits corrections because the pigments are not absorbed into the paper. Experiment with different brands of paper and you will find the paper that is right for you.

My Paper Choice. I like the medium texture of cold-press paper. My favorite paper to paint on is Arches 300-lb (640gsm) cold-press, which is internally sized, acid free and 100 percent cotton. I like this paper just as it comes from the factory, but many artists prefer to remove some of the sizing with a clean, damp sponge before they start painting. Try it both ways to find out how much sizing you want on the surface of the paper.

More Materials

Brushes

My first serious watercolor brush was a no. 12 round. It had synthetic "hairs." I couldn't afford a Kolinsky sable, or red sable. I didn't know about ox hair or sabeline or squirrel hair. I thought camel hair was a coat, and I thought bristle brushes were reserved for oil painters. I bought a synthetic brush because it was the best buy at the time. I discovered I was happy with my synthetic brush because it had a firm bounce when it made contact with the paper. I liked that. I used it a lot and learned to use it well. I bought more synthetic round brushes in different sizes. I found I liked round brushes because they carry more liquid than flat brushes. Most of my painting is still done with round, synthetic brushes in a variety of sizes. However, when I need to cover a large area or apply a glaze, I use a 1-inch (25mm) flat Aquarelle brush. I like my brushes best when they are broken in and the sharp tips are slightly worn to a pleasant curve. Some are so pleasantly broken in they look like they should be discarded. They are my favorites!

Brushes are as personal as paints. Find the ones that feel right in your hand. Use them a lot and some will become your favorites. Very inexpensive brushes are not a bargain. They will leave hairs in your paint, and they won't return to their original shape. You'll wish you'd paid a little bit more!

Practice!

You need to use good materials when you paint. However, the best supplies won't guarantee a masterpiece. Quality materials will do more to help you paint than hinder your progress. Quality materials combined with practice will make you a better painter.

Palette

I like a large, flat mixing area because I mix big, juicy washes! A John Pike palette, with its large mixing area and lid that serves as an additional mixing area, meets these needs. It's made of sturdy plastic and has twenty wells for holding paint.

I keep several John Pike palettes filled with exactly the same paints in exactly the same order (so my hand automatically knows where to find the right color), picking up a new palette when the one I'm working on gets too soggy. If you find you don't want to paint with a soggy palette, you may want to keep identical palettes and let one dry while painting with the other.

Paints

Paints are very personal. Over the years I learned that the same colors won't work the same way for every artist. The paints on my palette are the result of trial and error. They work for me. I'm happy with them today, but I'm not afraid to try new colors. I presently use mostly Winsor & Newton tube watercolors. Recently I've added some Daniel Smith Quinacridone Colors to my palette. Try paints from several manufacturers to find the ones that work best for the price you are willing to pay.

Paints Have Personality. Every color has a personality. Each is different from the other, not only in hue, temperature, intensity and value, but in how they act when they are applied to the paper. It's important to know a few of their traits.

Will the Color Last? A very important characteristic of paint is its lightfast rating. Some brands use "I" for excellent, "II" for very good, "III" for fair and "IV" for fugitive (fugitive colors fade when exposed to light). Other brands use stars: "★★★★" for excellent, "★★★" for very good, "★★" for fair and "★" for fugitive. Many brands use numbers or letters for their ratings. Choose paints that fall into the "excellent" or "very good" category. If you use fugitive colors, you may have a bright painting today and a dull painting tomorrow!

What Grade Is the Paint? Watercolors come in grades. Student Grade watercolor paints contain less pure pigment and more fillers and extenders. Professional Grade watercolors contain the highest quality of pigments that produce the best flood of color and maximum clarity of color. Artist Grade is usually somewhere in between.

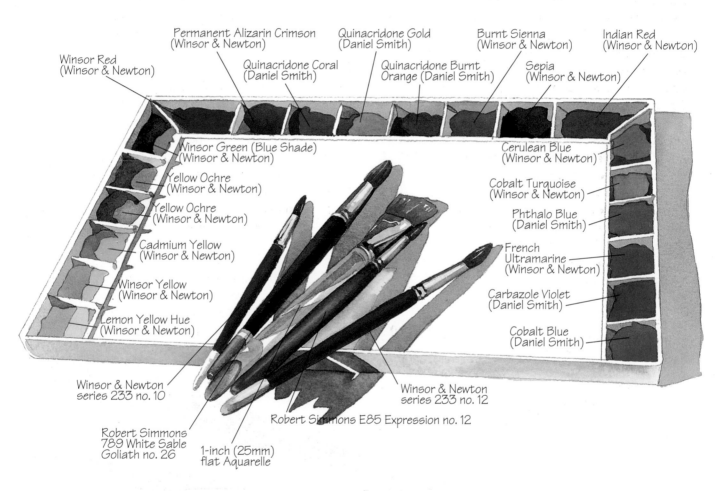

Paints and Brushes

The colors on my palette are arranged, with a few exceptions, like a color wheel. I keep the yellows together on the left side of my palette, the reds at the top, and the blues on the right. The colors on my palette are colors I have developed a preference for over my years of trial and error. I use some colors much more than others, but they all prove useful when I paint.

Note: I use two Yellow Ochres, one to mix with cool colors and one to mix with warm colors; Winsor Green (Blue Shade) is placed by Winsor Red, as I mix these colors to create black; Indian Red is placed by Cerulean Blue, as I often mix the two to create a rich gray.

How Transparent Are "Transparent Watercolors"?

Watercolor paints can be transparent, semitransparent or opaque. Transparent colors allow more of the reflected light from the paper to come through. Opaque colors kill some of the reflected light from the paper.

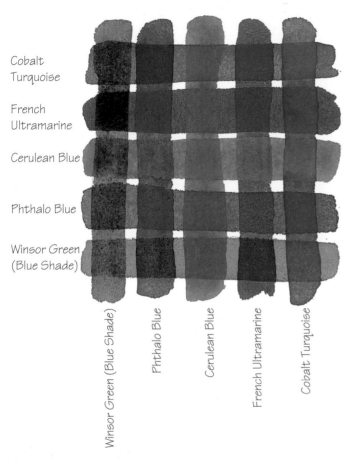

Cobalt Turquoise

French Ultramarine

Cerulean Blue

Phthalo Blue

Winsor Green (Blue Shade)

Winsor Green (Blue Shade)
Phthalo Blue
Cerulean Blue
French Ultramarine
Cobalt Turquoise

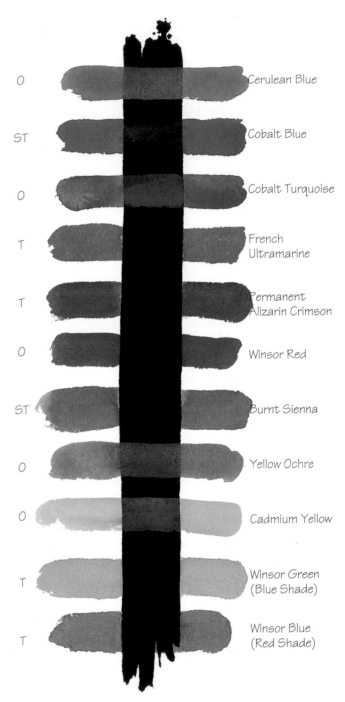

O — Cerulean Blue

ST — Cobalt Blue

O — Cobalt Turquoise

T — French Ultramarine

T — Permanent Alizarin Crimson

O — Winsor Red

ST — Burnt Sienna

O — Yellow Ochre

O — Cadmium Yellow

T — Winsor Green (Blue Shade)

T — Winsor Blue (Red Shade)

Transparent and Opaque Colors Working Together
Create a "plaid" using transparent and opaque colors to see how they work together. You will find that transparent colors, even when they are overlapped, allow the white of the paper to shine through. Overlapping opaque colors kills the luminosity. Compare the square created by the two stripes of French Ultramarine with the square created by the two stripes of Cerulean Blue. Layers of French Ultramarine remain transparent, while layers of Cerulean Blue are opaque.

Testing for Transparency
It's simple to test the transparency of your paints. First, paint a stripe of black India ink on watercolor paper. Let it dry completely. Brush a wash of the color you are testing across the stripe of dried ink. The paint will partially cover the black that is underneath, disappear completely or be somewhere in between. You will clearly see which paints are transparent (T), semitransparent (ST) or opaque (O).

Which Colors Stain?

Staining colors do just that: They stain the paper. While they are still wet they mix beautifully together and can be adjusted even on the surface of the paper. But when they dry they become part of the paper! You can glaze over dry, staining colors again and again and they won't dissolve, fade, bleed or mix with the fresh wash.

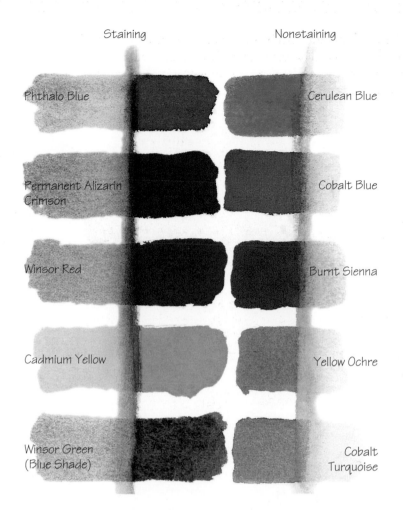

Staining Nonstaining

Phthalo Blue Cerulean Blue

Permanent Alizarin Crimson Cobalt Blue

Winsor Red Burnt Sienna

Cadmium Yellow Yellow Ochre

Winsor Green (Blue Shade) Cobalt Turquoise

Find the Staining Power
Determine the staining power of a color by brushing a wash of the color you are testing on a clean piece of watercolor paper. When it has dried completely, use a clean, damp sponge to see how much of the dried paint you can remove. Those colors that now seem to be a permanent part of the paper are staining colors. Try not to get staining colors where you don't want them!

Removing Dry Paint
Sometimes you paint over an area you wanted to remain white. Removing dried pigment is possible if you've used a nonstaining paint. In these samples a circle stencil and a damp sponge were used to remove as much pigment as possible. As you can see, it is possible to remove almost 100 percent of the pigment from Cerulean Blue and Burnt Sienna, both nonstaining colors. The staining colors, Winsor Red and Winsor Green (Blue Shade), have left the paper permanently colored. The white of the paper is gone!

Know Your Paints
Do you need to know these characteristics? Maybe. Is it important to know the technical qualities of every tube of paint? Probably not, unless, for example, you love Winsor & Newton Cerulean Blue. It's a nonstaining, opaque paint. If you switch brands to Daniel Smith Cerulean Blue you'll find it is a low staining, semitransparent paint. The two Cerulean Blues won't produce the same results, and if you understand the characteristics of each, you'll know why.

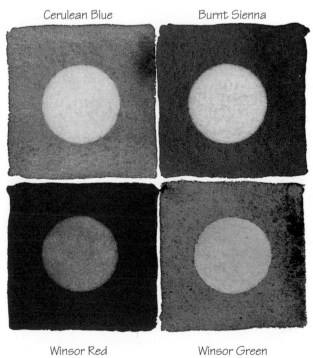

Cerulean Blue Burnt Sienna

Winsor Red Winsor Green (Blue Shade)

The Purest Form of Color

Colors differ in four ways: hue, temperature, intensity and value. The relationship of one color to another can best be understood when colors are arranged in a circle known as a *color wheel*. The color wheel shows the purest form of each color. This pure form is called the *hue*.

The three primary hues are red, yellow and blue. The secondary hues are created by combining two of the primary hues: Red mixed with yellow makes orange; yellow mixed with blue makes green; blue mixed with red makes violet. A primary hue and its adjacent secondary hue can be mixed together to create a tertiary hue. For example, red can be mixed with violet to create red-violet. The purity of the color has not changed, but the hue has.

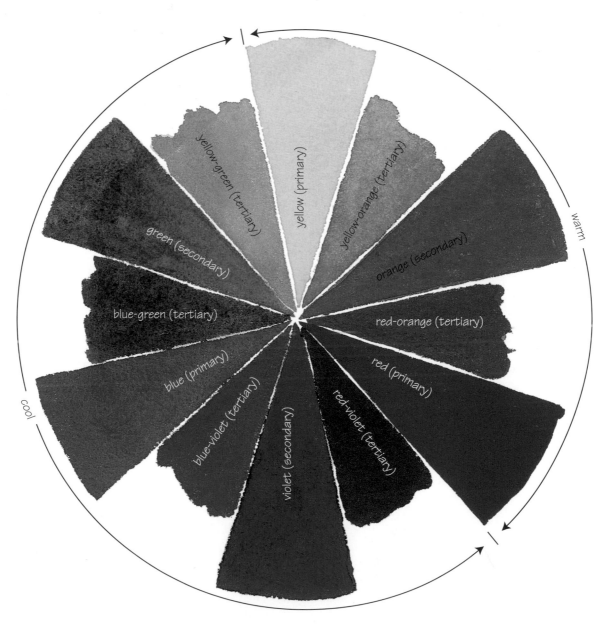

Color Wheel
A color wheel shows the relationship of one hue to another. A simple color wheel is made up of the primary hues (yellow, red and blue), the secondary hues (orange, green and violet) and the tertiary colors (yellow-orange, red-orange, red-violet, blue-violet, blue-green and yellow-green). Every hue has a complement hue that is found directly opposite on the color wheel.

Color Temperature

The temperature of a color is classified as warm or cool. There is a very easy way to differentiate between the two: Any color that looks like it has any amount of blue in it is classified as a cool color. The rest are warm.

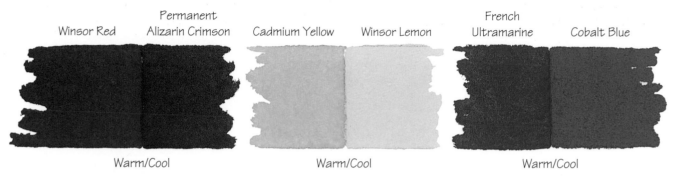

| Winsor Red | Permanent Alizarin Crimson | Cadmium Yellow | Winsor Lemon | French Ultramarine | Cobalt Blue |

Warm/Cool Warm/Cool Warm/Cool

Warm and Cool Colors
There are warm reds and cool, warm yellows and cool, and warm blues and cool. Warm blues are classified as cool colors because any hue that contains even the smallest amount of blue falls in the cool category.

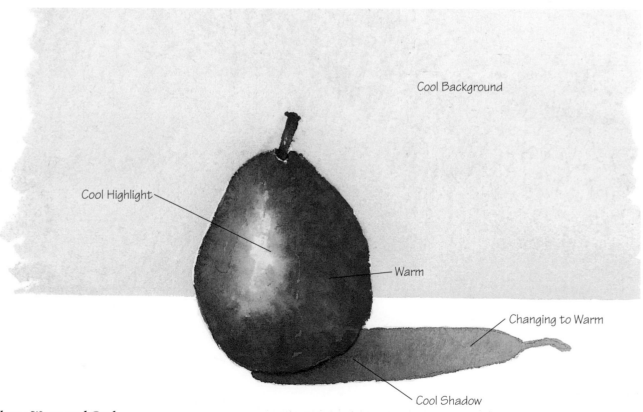

Cool Background

Cool Highlight

Warm

Changing to Warm

Cool Shadow

Balance Warm and Cool
You can emphasize the richness of warm colors by using cool accents. The warmth of the pear is enhanced by a cool highlight (just a hint of Cerulean Blue) and a cool background. The shadow appears "grounded" because Cerulean Blue (cool) is added to Burnt Sienna (warm) directly under the pear. The shadow gradually changes from cool to warm as it moves farther away from the pear.

Color Intensity

Color intensity is the brightness or dullness of a color. The brightest intensity of any color is its *hue*, the color you get when you squeeze fresh paint from the tube. If this color is too bright you can dull the intensity by adding a little bit of its complementary color (the opposite color on the color wheel). It will lower the in-tensity and is called a *tone*. If you want to tone down a bright orange, add a touch of blue. If a yellow is too in-tense, add small amounts of violet until you have the tone you desire. Green can be toned down with its complement, red. Many beautiful browns are created by using mixes of complementary colors.

Making Tones

The intensity, or tone, of a color is changed by adding a little of its complement (the opposite color on the color wheel). Theoretically, if opposite colors are mixed in equal amounts, the resulting color will be a neutral gray.

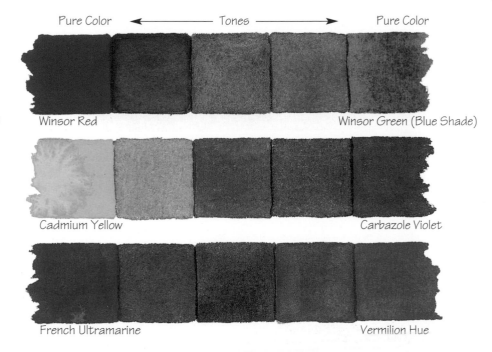

Pure Color ⟵ Tones ⟶ Pure Color

Winsor Red · Winsor Green (Blue Shade)

Cadmium Yellow · Carbazole Violet

French Ultramarine · Vermilion Hue

When two complementary colors are placed side by side, each color becomes intensified. Here Winsor Red and Winsor Green (Blue Shade) are used. Blue placed next to its complement, orange, will cause an optical illusion that makes each appear brighter. Red placed next to green causes the eye to jump from color to color. A bright yellow placed next to a bright violet creates the same vibration. Too much intensity can be hard to look at for any length of time. Tone down an intense color by mixing it with its com-plementary color.

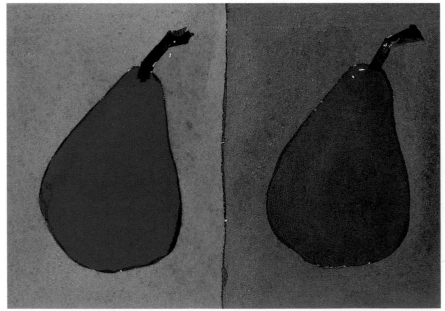

High Intensity · Low Intensity

Color Value

Value refers to the lightness and darkness of a color. To darken a watercolor pigment you may add any one of the many tube blacks available on the market. Common names for black are Ivory Black, Lamp Black, Blue Black and Neutral Tint. Neutral Tint is a "black" that doesn't have blue or brown undertones. I recommend using it to darken a pigment without changing the color.

Adding black to a color makes the color darker in value and is called a *shade*. Adding white to a watercolor pigment is easy: Add clear water in varying amounts! The "white" comes from the surface of the paper. Adding clear water makes the color lighter in value and is called a *tint*.

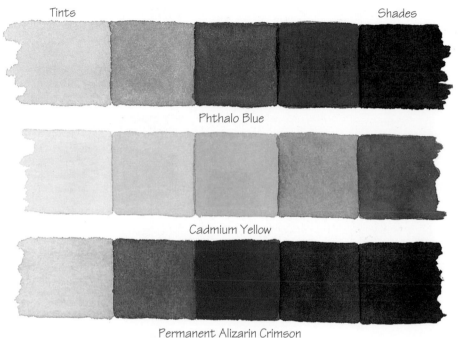

Tints

Shades

Phthalo Blue

Cadmium Yellow

Permanent Alizarin Crimson

Making Darks and Lights

Add Neutral Tint to darken a color and make shades. Dilute your colors with clear water to lighten a color and make tints. Avoid using Chinese White watercolor paint to alter colors. It is opaque, and tints made with Chinese White look chalky. If you want your tints to sparkle, dilute your paint with clear water and allow the white of the paper to reflect through your color.

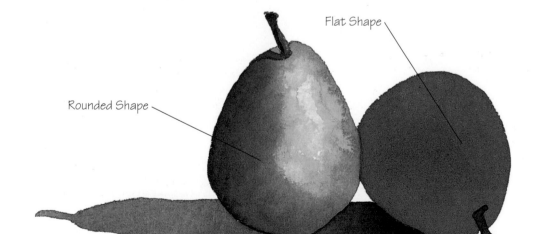

Flat Shape

Rounded Shape

Creating Dimension

Value changes create the feeling of the third dimension on a flat piece of paper. By painting lights and darks, a flat object can be transformed into an object with depth. The pear on the right appears flat, while the pear on the left appears round because the darks recede and the lights come forward. Using a wide range of value in your painting is an effective method of emphasizing the effect of light.

Seeing Light

Finding images to paint is like shopping. Sometimes it's a chore. The fit isn't quite right or the color isn't good. Sometimes you settle for the less than perfect. Sometimes you come home empty-handed. But sometimes you find it! What a feeling of satisfaction that gives! "Seeing" a painting for the first time evokes exactly the same feeling, maybe more so, depending on how much you like to shop! It's the most inspirational part of the painting process. It's like magic! Your mind's eye takes over and you start painting in your head. The image is etched into your brain and you have to get it on paper. But what made you see an image in the first place and know it would become a painting? It was probably the light.

What to Look For

How do you see light? Look for light shapes, shadow shapes and contrasts! You might even find them when you're not looking. Be prepared to catch that light.

What Was There
This house isn't very noticeable on an ordinary day.

Light Changed It
Early one morning I was driving past the house just as the sun was peeking through the trees. Wow!

What I Saw
The light changed an ordinary house into simplified shapes of light and dark that could not be ignored.

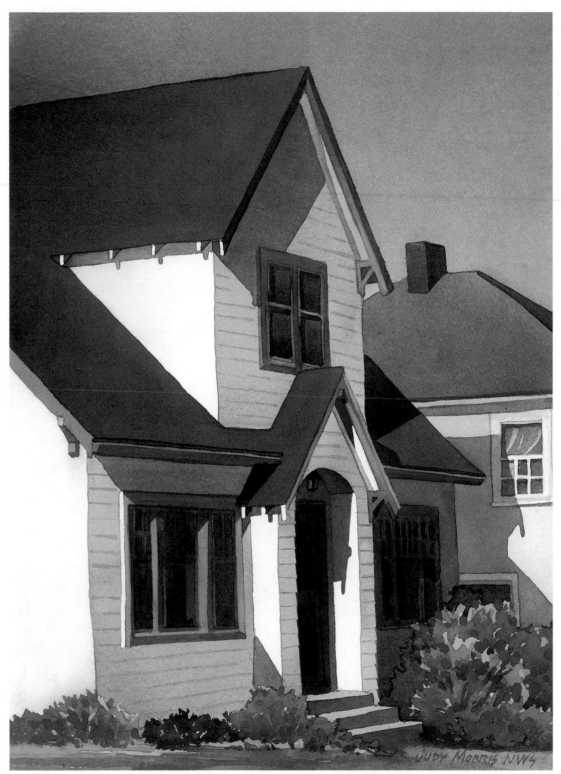

The Painting

Being in the right place at the right time to see light transform an ordinary object into a dramatic object really inspired me.

House on Main Street
16½" × 12" (42cm × 30cm)

Catching Light Quickly

Light changes quickly. You have to be able to capture the light that caught your attention in the first place. It must be done before the light changes. You may not have much time.

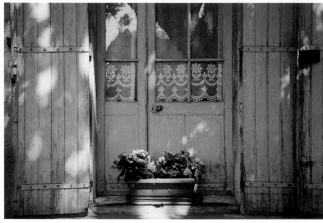

Using the Camera
The camera captures a special moment and can freeze light and shadow in less than a second. Photographs record light with 100 percent accuracy and are useful references for studio painting.

B.C. MINI MARKET. GRAND CAYMAN - BRITISH WEST INDIES

Pencil Sketches
Quick thumbnail pencil sketches capture light very quickly. Gradations of light and dark are created by shading with a soft lead pencil. Try drawing your thumbnails with a 6B graphite pencil, and use a soft, white eraser for corrections. Sketch on smooth, acid-free paper.

Pen-and-Ink Sketches
Pens with felt, fiber or plastic tips are widely used for sketching. Sketches made with these pens are free and spontaneous because the lines they make cannot be erased! Since the ink in many of these pens consists of dyes and not pigments, they will fade when exposed to light for any length of time. Choose a pen with permanent ink for your "permanent" artwork!

Sketching Light

Whether you are in Paris or your own backyard, you can capture the essence or mood of the moment by making quick sketches. Sketching allows you to respond not only to the subject in front of you, but also to the atmosphere around you as well. The sounds, smells and climate conditions become part of the ambience of "being there." Your renderings of the way light, the dominant factor in determining the mood of a painting, affects the subjects you are drawing will contain more of the presence of place than anything that could be recorded with a camera.

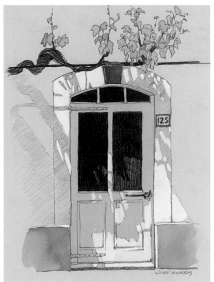

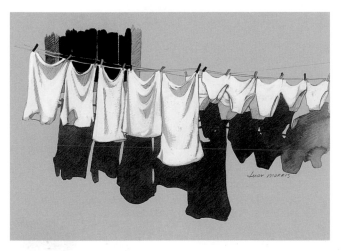

Working on Colored Paper

You can catch light quickly when working on tinted paper. The color of the paper represents the midtones. Add darks with a 6B pencil and lights with white paint. First sketch the image that caught your eye. When your basic drawing is complete, suggest color with a few watercolor washes. When the image and the color are recorded, use white paint to quickly record the lights, and pencil shading to quickly record the darks. This method allows time to do the drawing without worrying about moving shadows.

The clothesline (at left) is painted on Somerset paper (newsprint). The doorway (above) is painted on Arches Cover (buff). The white paint is interior, flat latex wall paint I found in the garage. I take it on location in an empty plastic shampoo bottle.

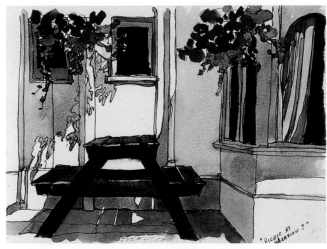

I make watercolor sketches on location with a Sanford Expresso medium-tip pen. The ink is not lightfast, but it doesn't need to be because my watercolor sketches won't be exposed to light over an extended period of time. I have a travel watercolor palette filled with my twelve favorite colors. I use a Daniel Smith no. 10 travel brush and paint in a 10" × 7" (25cm × 18cm) Canson Montval Watercolor Book.

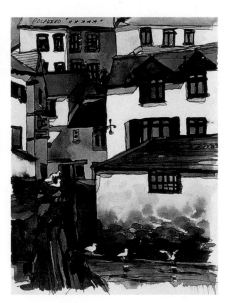

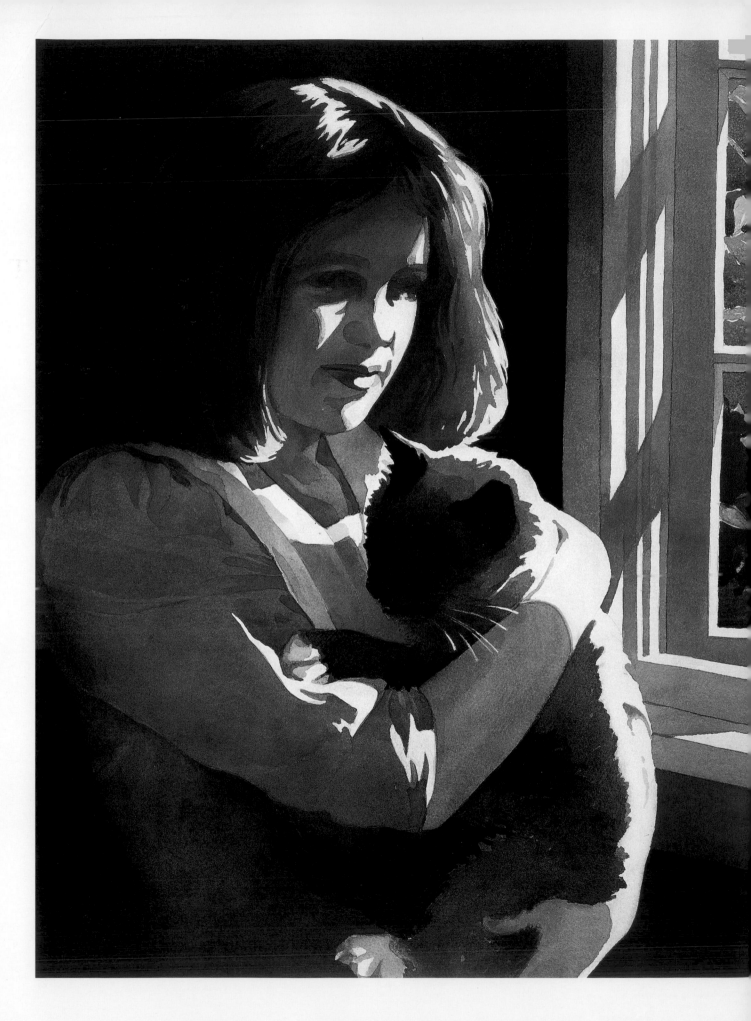

ATTRACTING ATTENTION WITH LIGHT

The subjects we paint don't have to be complex, exotic, elaborate, mysterious or difficult. They only have to attract attention! When the light is just right, ordinary becomes breathtaking. And breathtaking gets our attention!

Capture the feeling of light in your paintings by recognizing, evaluating and painting contrasts. Train your eye to see changes in light and dark that create contrast in the images you paint. Use color temperature and color tone to heighten contrast. Honestly evaluate your work to determine if your contrasts are strong enough to attract attention. By painting and emphasizing contrasts you will be capturing light.

Sarah and Waylon
19½" × 21½" (50 cm × 55cm)

Weak Contrasts

To help you understand the importance of contrast, I've made a painting that has some common mistakes. The subject is fun. The drawing is good. The design works. The use of contrast is not as good as it could be. Let's critique it.

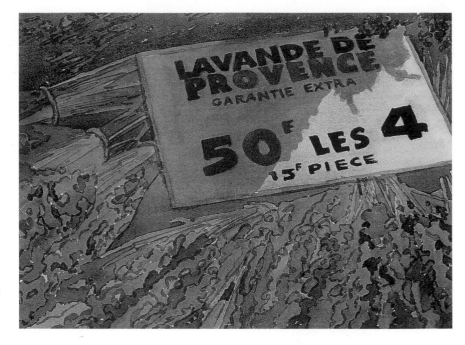

Make a black-and-white copy of your painting to check contrasts.

There is not enough contrast to see individual stems.

The shadow color is flat.

These blacks are not repeated anywhere else in the painting.

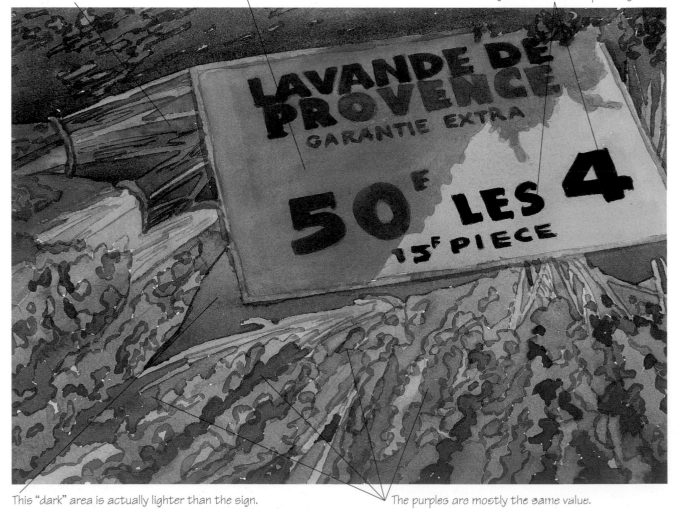

This "dark" area is actually lighter than the sign.

The purples are mostly the same value.

Strong Contrasts

This version of the same painting on the facing page sparkles with sunlight. It's the same drawing. It's the same design. The technical problems of using contrast have been solved. Let me show you why.

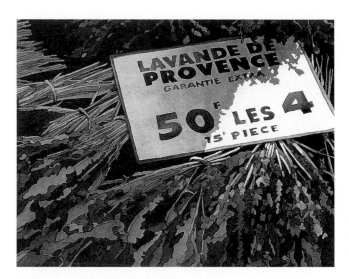

A black-and-white copy of this painting proves contrast is necessary to catch light

Contrast allows you to see individual stems.

The shadow is interesting because the color changes.

Paying careful attention to the edge of the shadow heightens the contrast.

The darkest lettering is in the shadow where it should be.

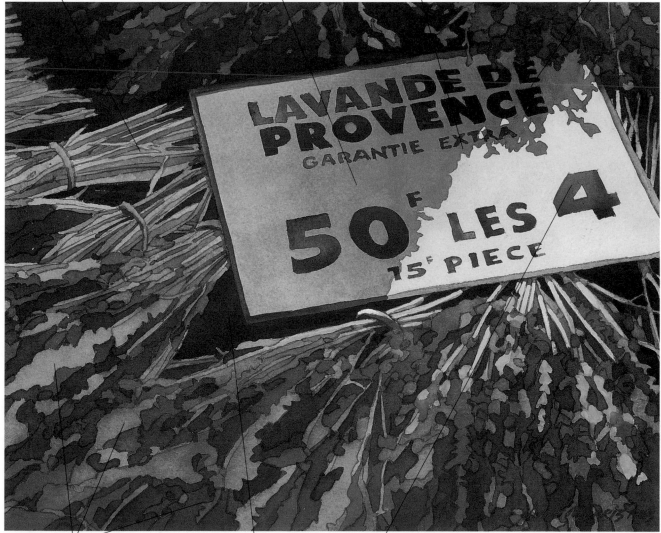

There is a good variety of light and dark purples.

The space behind the sign is very dark to show depth.

Painting the "4" lighter emphasizes the feeling of sunlight.

Lavande de Provence
10½" × 12½"
(27cm × 32cm)

Checking Your Contrasts

The most important technical part of painting light that must be conquered is understanding and effectively using value, the lights and darks that create contrast in your paintings. Train yourself to see and evaluate the value changes in your painting. Check values when the painting is in progress. Check values when you think you're finished. Remember that sometimes even small adjustments in contrast can make a big difference in painting light.

Copy Machine

I like to make a black-and-white copy on a copy machine to check my value contrasts. Fortunately, I have one in my studio—and it gets used often!

The paintings on pages 28 and 29 were photographed here through red cellophane. Look how the red neutralizes the color and emphasizes contrast or lack of contrast. Try to give your paintings as much contrast as shown in the lower image.

Squint Your Eyes

The easiest, always-there method of checking value contrasts is squinting your eyes when you look at your work. Your eyelashes act as a feathery screen, causing the color to neutralize. You will see less color and more value.

Look in a Mirror

Stand ten feet away from a mirror and view your painting backwards. The color won't disappear, but since you're looking at your work from a distance and backwards, you will see it with a fresh eye. If parts of your painting disappear or run together, strengthen the contrasts to define the shapes.

Look Through Red Plastic

View your work through a piece of red plastic or cellophane. The red neutralizes everything into shades of red. Again, if any shapes in your painting disappear or run together, you need to intensify contrasts.

Tracing Paper

Put several layers of tracing paper over your painting. It's like putting your painting in a "fog." If you can see your painting through the fog, you have enough contrast.

Video Camera

You see images in black and white and shades of gray through the viewfinder of most video cameras. If you own a video camera, look through the viewfinder to check your values. You may not even have to turn the camera on.

Sunglasses

Put on your sunglasses—the darker the better (inexpensive, plastic, wraparound, dark glasses made for post-surgery patients are the best). You will be looking through the green or gray of the lens, but the color in your painting will be neutralized and it will be easier to focus on value.

Digital Camera

Digital cameras are becoming popular. If you have one, use it. Put the image of your painting in your computer. Change the color option to black and white. Technology works!

Focus On Light and Dark

Many artists paint from color photographs because the camera is so efficient in capturing the inspiration that attracted attention in the first place. A sunny view or a perfect shadow (don't we all have hundreds of these photos!) is easily caught on film to be used as future reference material. These photographs, most likely, are not perfect. They are "points of departure" for paintings and will need adjustments in color, composition and value to transform them from good photographs into great paintings

More Important Than Color
Before color television (some of you will be able to remember!) we watched "value" every night. It was easy to see black-and-white and shades of gray. It's harder now. We have to train our eyes to remove the color and concentrate on value because the values used in a painting are more important than the colors. Bring light into your paintings by learning to see and paint strong value contrasts.

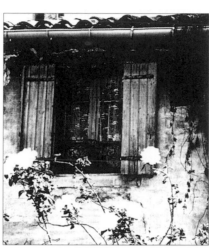

Value Plan
The reference photograph is colorful and inspiring, but the values are confusing. Create a value plan by running the photograph through a copy machine to simplify the shapes into a pattern of light and dark. Refer to your value plan as you paint to intensify the feeling of light.

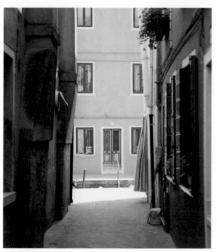

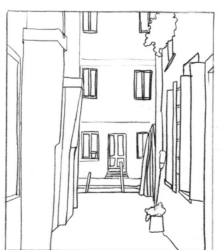

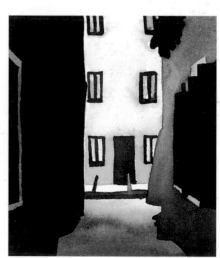

Value Plan
A value plan can also be created without a copy machine. Place a piece of tracing paper or tissue over your reference photograph and draw an outline around the darkest, middle-value and lightest shapes. Leave the lightest shapes white. Color the darkest shapes black, and fill in the middle-value shapes gray. Use this plan to check your values as you paint.

Color and Value Contrasts

Color

Everything has color. Everything we see, everything we buy and everything we paint has its own unique hue. It's a difficult decision to choose exactly the right color because there are about a zillion choices. (Who hasn't thought a color looked just right on a paint chip but looked wrong when the room was painted?) Don't let color confuse you. Become familiar with the qualities of color: hue, temperature, value and intensity. Learn to control color by painting a lot. If you are just beginning, keep your color choices simple. Add colors to your palette as you become more "color confident." Your personal color style will emerge, and you will be able to control color with assurance.

Value

It's harder to see value because color gets in the way. We can name colors easily. We can categorize colors into families, usually the primary and the secondary color groups. A dress might be described as "violet with just a bit more blue in it." Almost everyone will see that color in their mind. Values are more difficult. It's not as easy to describe a specific gray, as it is a specific color. A pair of shoes "just a touch darker than the step above middle gray on a value scale" doesn't recall the same gray for everyone.

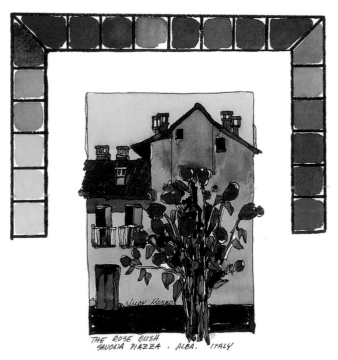

Color Contrasts

Learn more about your colors by painting a color sample that represents your palette. Use clear water and make each color as pure as possible. Choose two complementary colors as the focus of a small painting. Here I painted the roses as red as I could get them so they would contrast strongly against the green leaves. The contrasts are strong and seem to work.

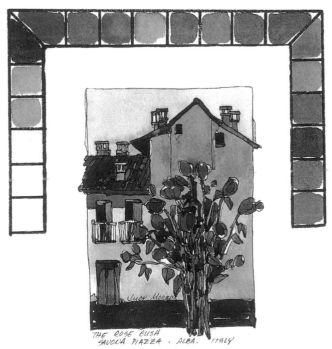

Value Contrasts

Make a black-and-white copy of the color sample that represents your palette. The copy machine turns your colors into their relative value. You will see the exact value of each color you are using. Some of the values may surprise you. Look what happened to the rose bush; red and green read as the same relative value and the contrast disappeared. That rose bush wouldn't make a good focal point in a painting because it wouldn't attract attention.

The Value of Color

Every color has a relative value. That means a color is very light, very dark or somewhere in between. Yellows are the lightest colors on the color wheel. Orange and yellow-green are the next lightest colors. The reds, blues and violets are among the darkest in value. However, there are hundreds of yellows, reds and blues. Each specific color will have its own unique relative value. For example, Cerulean Blue has a lighter relative value than French Ultramarine. Since correct values are so important in painting the effects of light, it is important to know the relative value of the paints you are using.

Value Scales

Learn to see value by making value scales. Start with a black-and-white value scale. A good "black" to use is Neutral Tint because it does not have blue or brown undertones. Use it full strength to make the darkest segment of a value scale. Add clear water to gradually lighten each segment until you have created the lightest gray. Be sure you can see the divisions between the values, because you can't train your eye to see differences if there isn't a contrast.

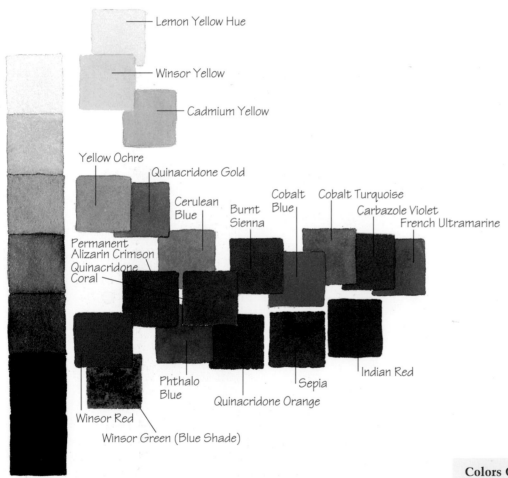

Lemon Yellow Hue

Winsor Yellow

Cadmium Yellow

Yellow Ochre

Quinacridone Gold

Cerulean Blue

Burnt Sienna

Cobalt Blue

Cobalt Turquoise

Carbazole Violet

French Ultramarine

Permanent Alizarin Crimson

Quinacridone Coral

Phthalo Blue

Quinacridone Orange

Sepia

Indian Red

Winsor Red

Winsor Green (Blue Shade)

Chart the Relative Values of Your Colors

Make a value scale with seven distinct value divisions.

Paint a full-saturation sample of each of your colors. (Full saturation means you add just enough water to the paint as it's squeezed from the tube to make it workable.) Then run these color samples through a black-and-white copy machine to turn each color into a value.

Using the photocopy of your colors for guidance, paint a sample of each color where it falls in relationship to the value scale. Refer to your chart to help you paint the contrasts you need to make your paintings glow with light.

Colors Can Surprise You
Yellows have the lightest relative value when painted at their full saturation. I expected Winsor Yellow to have the lightest relative value on my palette. I expected Winsor Red and Winsor Green to be among the darkest. I didn't know I had so many "dark grays" on my palette!

Simplify Color: Monochromatic

You will learn to paint contrasts when you use a monochromatic color scheme (one color with tints and shades of that color). Color choices are eliminated. Concentrate on the values. Your paintings will attract attention!

Make value scales with your favorite colors. Add Neutral Tint to darken a color and make shades. Dilute your color with clear water to lighten a color and make tints. Again, be sure you can see the divisions. Soon you will be able to see value instead of color.

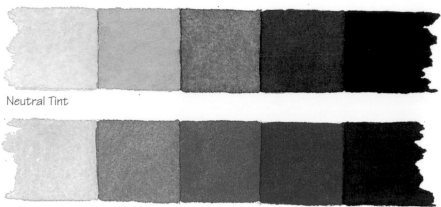

Neutral Tint

French Ultramarine

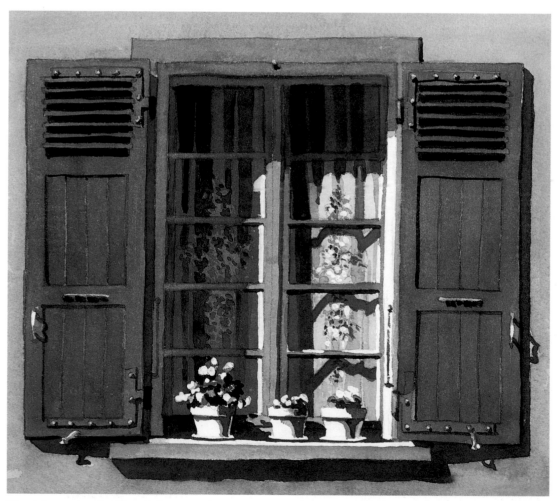

The rich contrasts in this painting are hard to ignore!

Window #1
Jacque Brown
9½" × 10½" (24cm × 27cm)

Simplify Color: Limited Palette

Too much color can be as confusing as looking in a kaleidoscope! Sometimes there are so many choices it's hard to focus. You think you want color, but you're really looking for value and don't know how to find it. The simple solution is to paint with a limited palette for a while.

Painting With Triads

Painting with a triad means limiting your color choices to one of each primary color: red, yellow and blue. Choose three colors that have similar characteristics to achieve harmony. The three colors you choose can be very transparent, such a Permanent Alizarin Crim-son, French Ultramarine and Winsor Yellow. Rose Madder Genuine, Burnt Sienna and Cobalt Blue are three granulating colors that work well together. You can try using the "opaque" colors in the Desert Triad: India Red, Yellow Ochre and Cerulean Blue. By using a triad you will be less concerned with color and more focused on balancing lights and darks.

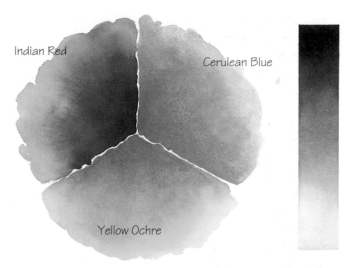

Indian Red

Cerulean Blue

Yellow Ochre

Desert Triad
Like all other triads, the Desert Triad consists of three colors that represent the primary colors on the color wheel. They create a limited range of color but a wide variety of values (notice the value scale created with just these three colors).

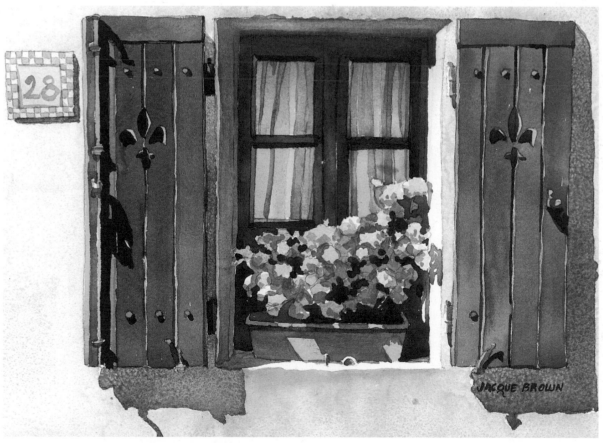

This painting was created using only the Desert Triad. The color is completely under control and the value contrasts are splendid!

Window #2
Jacque Brown
10½" × 13½" (27cm × 34cm)

Light and Composition

Light has inspired artists from the earliest recorded drawings found in the caves at Lascaux, France, until today. The study of light has changed art history. The search to capture light has inspired artists to make radical changes in tradition. Seeing and recording light has been a steady inspiration for artists worldwide. Rendering light on canvas or on paper has been subtle and it has been bold, but it has never been ignored.

When light is your inspiration you need a few simple design tools to help turn that initial inspiration into a good composition. You want to showcase light using the best underlying design possible, because just as a skeleton gives shape to the human form, the underlying composition is critical in making a painting work. Here are a few basic rules to help you plan your light-filled paintings.

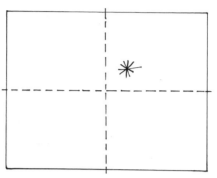

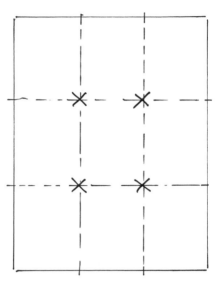

Focal Point

When we learned to read, our eyes were trained to move from left to right. That is the easiest path for our eyes to follow. For that reason, the most effective composition to read is a horizontal format with the focal point above and to the right of center. Showcase the light in your paintings by placing the most contrast between light and dark above and to the right of the center for the best impact.

The Golden Mean

Subject matter may require more choices for a focal point in your paintings. The Golden Mean gives you these choices. Divide your paper into thirds, either horizontally or vertically, and place shapes with the most contrast between light and dark at one of these intersections.

Don't Divide in Half

Always avoid dividing your composition in half horizontally or vertically. It's hard to achieve balance when you have to work with two halves that are the same weight.

Design Success

The success of each painting depends on the light it emits. By properly placing the focal point and following the rules of design, you can showcase the light in your paintings.

Design Do's and Don'ts

Don't wait until your painting is finished to check your design. It may be too late.

Do check your drawing to see if you've laid the best groundwork for a successful painting.

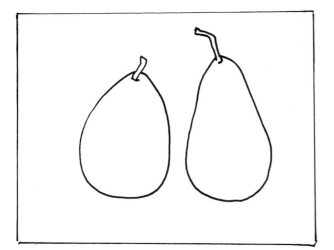

Don't separate all the shapes in your composition.

Do overlap shapes for a friendlier feeling.

Don't place your focal point in the center of the page.

Do move the focal point to the right or left.

Don't attach objects to a corner. *Don't* cut off any corner with a diagonal line.

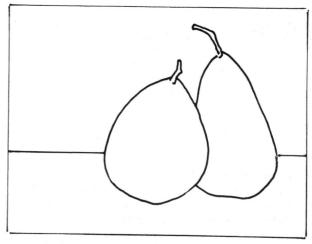

Do attach objects to the edge of your paper.

Composition and Contrast Create Light

Once you understand the concept of catching light with contrast, you are ready to paint! Look for subject matter that will not only be fun to paint, but that also offers you the opportunity to emphasize color and value contrasts arranged in a composition designed to showcase light.

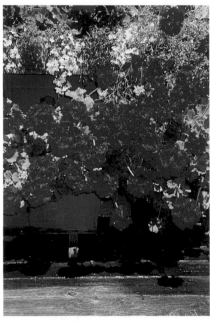

Use a Reference Photo
Use the reference photograph to create a design and value plan for the painting.

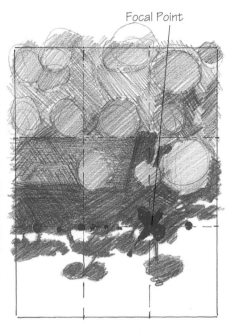

Design Value and Focal Point
Make a rough value sketch using light, middle and dark values.

Divide your paper into thirds horizontally and vertically (the Golden Mean), and place the focal point at the intersection where the right and bottom lines cross. Putting the most contrast near the "X" emphasizes the shadow that showcases the light. Fill the dark, midtones and light values in with a soft lead pencil to support the focal point.

Complete a Drawing
Create a drawing plan by simplifying the flower, leaf and shadow shapes into a contour drawing. It is important to carefully draw the edge of the shadow because that line divides the dark of the shadow from the light of the foreground, creating both the focal point and the illusion of strong sunlight.

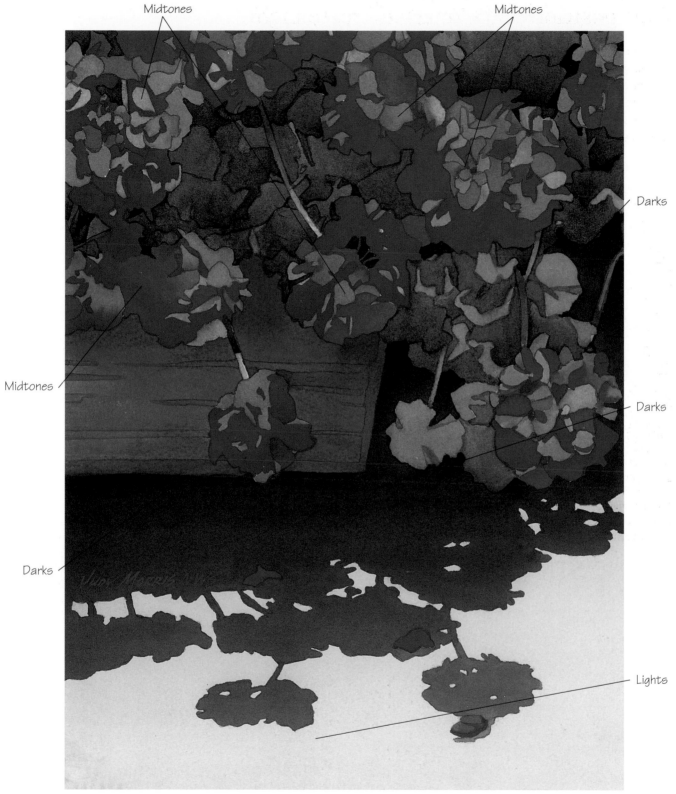

Midtones

Midtones

Darks

Midtones

Darks

Darks

Lights

Apply Color
Editing the photograph and making a value and design plan allowed me to place the contrast where it's needed. The dark shadow shape against the light foreground captures the feeling of sunlight.

Jacque's Geraniums
13½" × 10" (34cm × 25cm)

MAKING AND KEEPING LIGHTS AND DARKS

Watercolor painting is like marriage: There are many expectations and challenges. Both are unpredictable and demand compromise and patience. Good marriages and good watercolors require work and, sometimes, a lot of luck. When things go wrong you have to know how to fix them.

You can't always fix a broken marriage, but you can learn techniques that work when a watercolor painting needs fixing.

Mom, Can We Talk?
21" × 27" (54cm × 69cm)

Reserving Light

The white of the watercolor paper can be an artist's best friend. Its light-reflecting surface can make your colors sparkle. Carefully placed unpainted white shapes left on the paper may be even more important than the colors you've applied. The white you get from the surface of the paper fills your painting with the impression of light. When the white of the watercolor paper works with the artist, a painting is a success.

The easiest way to reserve the white paper is to paint around the shapes you want to remain white. This requires careful advance planning as well as skill in applying the surrounding paint. The smaller the white spaces you wish to leave, the more difficult this task becomes. But don't panic! There's help available. You can use tape, masking fluid or a clear wax crayon to help you reserve your lights.

Liquid Resists

There are several excellent liquid resists on the market. (This sample was made using Winsor & Newton Colourless Art Masking Fluid.) Apply the resist, which is a liquid latex, with a brush.

Clean your brush (please don't use your most expensive one!) with water immediately after applying the resist. Let the resist dry completely before applying a watercolor wash on top of it. After the paint dries thoroughly, gently rub the resist off with your fingertips or a rubber cement pickup made especially for this purpose.

Wax Crayon

The white of the paper can be reserved by rubbing or drawing on the surface with a white wax crayon. The wax adheres to the surface of the paper and, when a wash of color is applied, the wax resists the paint. The kind of paper you use determines the amount of wax resist. Drawing on hot-press paper, with its smooth surface, creates a solid line or area. You will get more texture on cold-press or rough paper because the wax adheres to the "hills" and not the "valleys," suggesting the texture found on rocks, tree trunks, and brick or stucco walls.

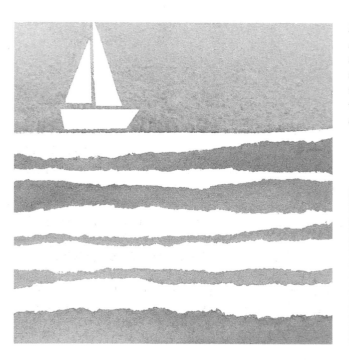

Masking Tape

Areas of white paper can be reserved by applying pieces of masking tape to the surface of the paper. Tear shapes from tape for soft, uneven edges (the horizontal white shapes) or cut shapes for precision contours (the boat and sails).

Protect Your Brushes

Follow these steps to avoid ruined brushes when using a liquid resist:

1. Dip your brush in clean water.
2. Rub the bristles across a bar of soap several times to coat each "hair" with soap.
3. Apply the liquid resist to the desired area.
4. Immediately clean your brush under running water to remove the soap and the liquid resist.

Exercise One
Using a Masking Fluid

Follow these basic steps to try your hand at using a masking fluid to reserve lights in a painting.

**Step 1:
Complete
Drawing and
Add Mask**
Draw this simple
basket sitting in
bright sunlight.
Use masking
fluid to reserve
the shapes you
want to remain
white.

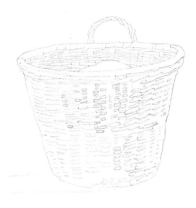

Paper
Arches 300-lb. (640gsm) cold-press
 watercolor paper

Palette
Burnt Sienna
Carbazole Violet
Winsor Red

Brushes
Round: no. 6, no. 8 and no. 10

Other
Winsor & Newton Colourless Art
 Masking Fluid
No. 2 pencil

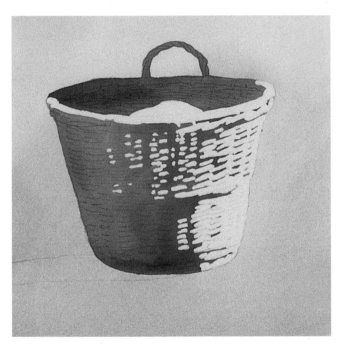

Step 2: Apply Washes
Mix a pale wash of Burnt Sienna and brush it over the entire paper with a no. 10 round brush. Let that wash dry completely. Mix a darker wash to accentuate contrast by combining Burnt Sienna and Carbazole Violet. Use more violet closest to the reserved highlights and apply the wash with the same brush.

Reverse the lights and darks on the inside of the basket. Make the wash darker on the left and apply it with a no. 8 round brush. When the last wash has dried, remove the masking fluid with your fingertips.

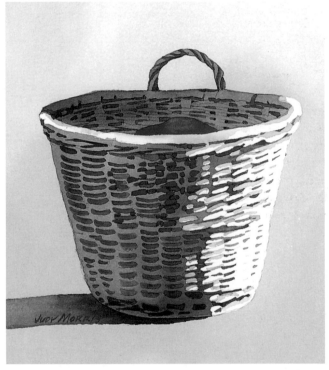

Step 3: Add Details
Mix Burnt Sienna and Carbazole Violet and add detail and define the weave of the basket with a no. 8 round brush. Let this mix vary to make the texture of the basket more interesting.

Add the shadow with this same color and same brush, making it darker near the basket. Soften the harsh edges left from the masking fluid, applying a pale glaze of Burnt Sienna with a no. 6 round brush. Be careful not to cover all the white! Add a touch of Winsor Red with the no. 6 brush for the cloth inside the basket.

The Red Cloth
8" × 9" (20cm × 23 cm)

Rescuing Light

Oops! You've painted over an area you wanted light. That doesn't mean you've ruined your painting! It only means you need to use one of the many techniques that will help you rescue the lost light.

Sponge Lift

You can remove big areas of paint fast by using a clean, damp sponge. If you're removing nonstaining colors such as Cerulean Blue, Cobalt Blue and Cobalt Turquoise in this sample, you can almost get back to the original white of the paper. Staining colors can't be removed as easily or completely. You will get fuzzy edges using this technique. Try creating cloud shapes in a blue sky by removing pigment with a sponge.

Brush Lift

It is easier to remove smaller areas of color using the brush-lift method than the sponge-lift technique. Apply clear water to the painted surface with a brush and let the water soak into the paper a little. Blot firmly with clean paper towels to remove the paint. Wet and blot again until you have removed the desired amount of pigment. Use this method to create diffused highlights or to soften edges.

Acetate Stencil

Using an acetate stencil gives you more control over edges when you remove paint with a sponge. Place a sheet of clear acetate over the painted area you want to remove. Trace around the shape with a permanent black marker. Remove the acetate and use a craft knife to cut the shape from the acetate. Place the stencil over the painted surface and use a clean, damp sponge to remove the paint. The edges remain crisp. Try "rescuing" the moon from a dark-blue sky.

Finding Light

Sometimes it is not possible to remove enough paint to find the light again. In that case you must perform "surgery"! You can use a typewriter eraser, sandpaper or a craft knife to recover lights. Save these techniques for when nothing else works because you will alter—and destroy—the surface of the watercolor paper!

Typewriter Eraser
A typewriter eraser can be sharpened to a fine point in a pencil sharpener, making it possible for you to adjust light in small areas. It works like fine sandpaper. Remove pigment by gently erasing the color. This method of paint removal is good for blending and softening edges between the white of the paper and a darker color.

Craft Knife
Use a craft knife to cut around the area you want white and peel off the top layer of the paper. Be careful not to cut through the paper! This works best when using thicker paper, like 300-lb. (640gsm).

Try using the craft knife to scratch light lines into dried paint to create textured effects. Scratching fine horizontal and vertical lines makes a perfect screen door!

Sandpaper
Use fine sandpaper to remove color from dried paint on cold-press or rough paper. Gently sand the "hills" and not the "valleys" of the paper to create a texture similar to dry-brush. Using a circular motion as you sand imitates the texture of the paper.

Caution! When you use sandpaper you have altered the surface of the paper. If you paint over a sanded area the pigment will soak in and your "rescued" light will become very dark!

Bleach
If you are painting on 100 percent cotton paper you can use diluted bleach to rescue a white area. Mix laundry bleach with an equal amount of water. Using a very old brush, apply the bleach mixture to the dried paint. Immediately rinse the brush under running water! The bleach works on the paint exactly as it does in removing stains from your laundry.

Adding Light

We have come to think of traditional watercolors as paintings that are based on transparency without the use of surface color or white paint. It wasn't always that way. Artists we think of as the greatest watercolor painters (Homer, Turner and Sargent) used what is known as "body color" for highlights in their watercolor paintings. Body color simply means surface color added to the painting. Surface color is pigment that is opaque and does not reflect light from the paper.

Surface Color

Common surface colors used to lighten areas in watercolor paintings are pastels and opaque watercolor paints known as *gouache*. There are advantages and disadvantages when these surface colors are used in conjunction with transparent watercolor. Gouache used as a surface color is opaque and leaves a matte finish that is fragile, can be easily marked and, when applied too thick, may crack and peel off. Pastel used as a surface color needs to be protected from accidental rubbing. You can do this by either spraying it with a fixative (not good for transparent watercolor) or by placing the work in a mat and behind glass. Using surface color is an alternative that offers the artist extra techniques that, when applied on top of transparent watercolor in small amounts, can be useful to lighten an area.

Adding Pastels

Colored pastels are opaque pigments that can lighten, darken or intensify the colors in a watercolor painting. They blend easily into the tooth of cold-press or rough paper better than they do on the smooth surface of hot-press paper. The effects of using chalk or pastels in conjunction with watercolor can be subtle or bold, depending on the amount applied. Applying chalk or pastels must be the last step in the painting process because it is not possible to apply a watercolor wash over this type of surface color.

If a substantial amount of chalk or pastel is applied, the painting takes on the characteristics of pastel and shows a powdery matte finish that must be protected against accidental rubbing. A fixative that binds the chalk or pastel to the paper surface can be sprayed onto the surface. A fixative will, however, seal the surface of the paper, changing a watercolor painting into a mixed-media painting.

Flame Red Gouache Winsor Red Watercolor

Adding Gouache

Gouache is technically an opaque watercolor paint. Gouache colors contain white or similar opaque ingredients that make them thicker in texture and not transparent. Because they are opaque you can apply light colors over dark colors with relative success. A heavy application of gouache completely covers the color under it, but if it is applied too thickly it may crack and peel off as it dries. Used as a surface color, gouache dries with a soft, matte, velvety appearance. Because gouache remains water-soluble when dry, applying a wash on top of it is difficult.

The Winsor Red transparent watercolor paint on the right looks very similar to the Flame Red gouache on the left when both are painted on a white surface. When the same reds are painted over dark green, the differences in opacity are clear. Transparent Winsor Red turns almost black, while the Flame Red gouache covers the green and stays intense.

Using White Paint

Bright light is interpreted most convincingly with watercolor when the white of the paper is left untouched. Leaving planned areas of pure white paper captures the sparkle and brilliance created by light. But watercolor is delightfully unpredictable, and so it's sometimes necessary to add opaque white paint to "rescue" the sparkle and brilliance of light.

There are many opaque white paints that are water-soluble and mix well with transparent watercolors. However, the character of transparent paint is completely changed when an opaque white is added.

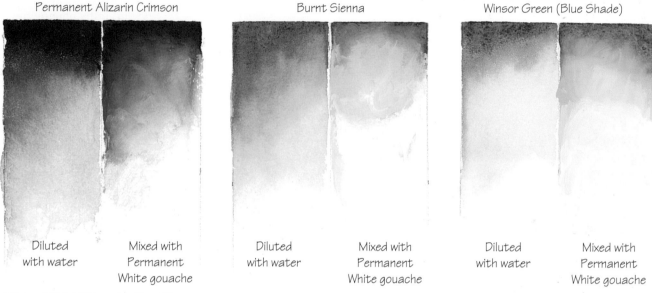

Permanent Alizarin Crimson

Diluted with water

Mixed with Permanent White gouache

Burnt Sienna

Diluted with water

Mixed with Permanent White gouache

Winsor Green (Blue Shade)

Diluted with water

Mixed with Permanent White gouache

Mixing With White—Making Tints

Watercolors remain transparent when they are diluted with water. Watercolors become semi-opaque when they are mixed with white paint, and a milky quality replaces the transparency.

Kinds of Whites

Permanent White gouache (A) dries with a matte finish and has a bluish undertone. This paint dries darker than it looks when it is wet.

Bleed Proof White (B) is a dense opaque paint. It has a smooth flow and good opacity, and can be used with a lettering pen for very fine lines. It is water-soluble and somewhat shiny when dry.

My favorite opaque white (C) exactly matches my favorite watercolor paper. I took a scrap of paper to the paint store and bought a quart of Interior Latex Flat Wall Paint, computer-matched to the watercolor paper. It covers completely and, when dry, has the same flat surface appearance as the paper. A quart lasts a long time; keep it fresh in the refrigerator!

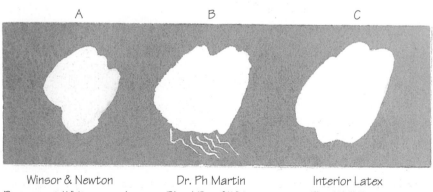

A — Winsor & Newton Permanent White gouache

B — Dr. Ph Martin Bleed Proof White

C — Interior Latex Flat Wall Paint

Using Black Paint

If you have light, you have to have dark. Sunlit areas would lack sparkle without the contrast of dark shadow areas. For the most impact, use the ultimate contrast—black against white—to emphasize the presence of light.

Black watercolor paint comes in several "colors." The subtle differences show up best when they are diluted with water and painted on a white piece of watercolor paper.

Mixed Black

My first watercolor instructor discouraged the use of a tube black. He insisted our paintings would be more colorful and the darks would be more interesting if we used a mixture of red and green instead of black.

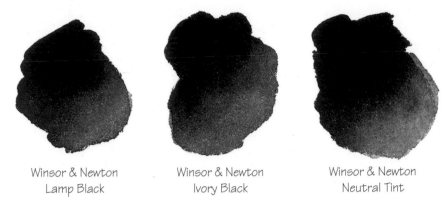

Winsor & Newton
Lamp Black

Winsor & Newton
Ivory Black

Winsor & Newton
Neutral Tint

Tube Blacks

The "black" in Lamp Black comes from mixing carbon or soot with a binder. It tends to have slightly bluish undertones.

Ivory Black is no longer made from charred ivory, but from charred bones. The undertones are warm and brownish.

Neutral Tint is made from synthetic black iron oxide. It will darken a color without changing its hue.

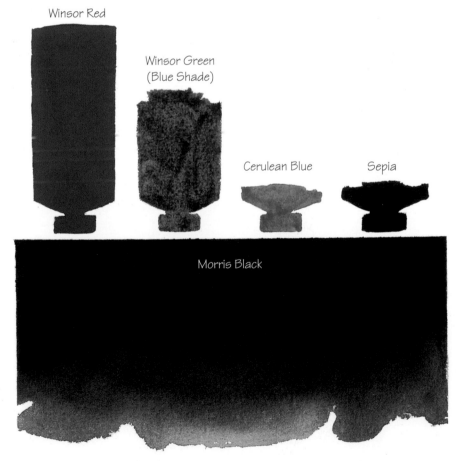

Winsor Red

Winsor Green
(Blue Shade)

Cerulean Blue

Sepia

Morris Black

Morris Black

To mix Morris Black, squeeze an entire 14ml tube of Winsor Red into a small plastic bowl. Add two-thirds of a 14ml tube of Winsor Green (Blue Shade), one-eighth of a 14ml tube of Cerulean Blue and one-eighth of a 14ml tube of Sepia. Blend these colors together, adding enough water to make the mixture the consistency of melted ice cream. Keep the bowl tightly covered in the refrigerator (so it doesn't mold!) and pour out small amounts of "Morris Black" as needed.

Comparing Grays

Gray is not the star in a painting. Black and white are the stars because they get the attention. We see light in the white and shade in the darks. But there would be no play if gray didn't bridge the gap between black and white.

Each gray has its own individual undertone. Payne's Gray, for example, has a bluish undertone, while Davy's Gray is more greenish. Grays with warm undertones are Charcoal Grey or Graphite Grey. The blacks and Neutral Tint diluted with water offer more gray choices. The richest grays, however, are made by mixing three colors that form a triad on the color wheel, one of each primary color: red, yellow and blue. The natural separation of mixed grays produces lively and colorful grays that are far more interesting than diluted mixes of tube grays or blacks.

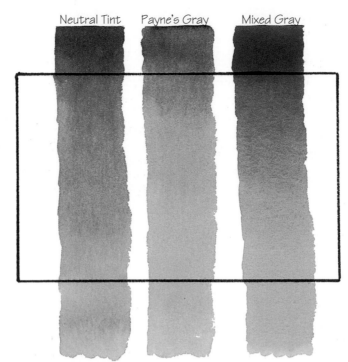

Neutral Tint Payne's Gray Mixed Gray

Types of Grays

The gray scale on the left is made with Neutral Tint diluted with water. It is very smooth and there is practically no color variation in the wash.

The middle scale was made using Payne's Gray. Here again, the wash is very smooth and there is no color variation in the wash.

The scale on the right was made by mixing three colors that create a triad: Indian Red, Cerulean Blue and Yellow Ochre. This mixed gray has tiny sparkles of color variation in the wash. The pigments settle into the tooth of the paper and create a liveliness that is both colorful and subtle at the same time.

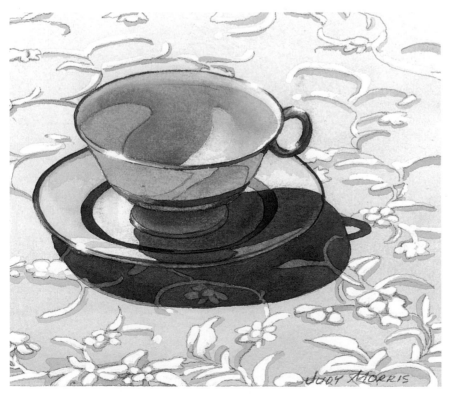

A "Gray" Painting

This painting of a white teacup on a white embroidered cloth proves an all-gray painting can be exciting! Close examination of the image reveals light, dark and midtone grays with yellow, red and blue undertones. Imitate the grays in this sample by mixing Yellow Ochre, Indian Red and Cerulean Blue in a wide range of values. The grays you mix will sparkle with colorful light.

Sam's Teacup
7½" × 6½" (19cm × 17cm)

Midtones and Shadows

Midtones in watercolors have to be interesting because there are usually more midtones in a painting than there are lights or darks. Most shadows are midtones. When light falls on a subject, the richest colors are in the shadows. Make sure the midtones you use for shadows are interesting and rich in color.

Using the correct values for shadows emphasizes the feeling of light. Darker values make more convincing shadows than lighter values.

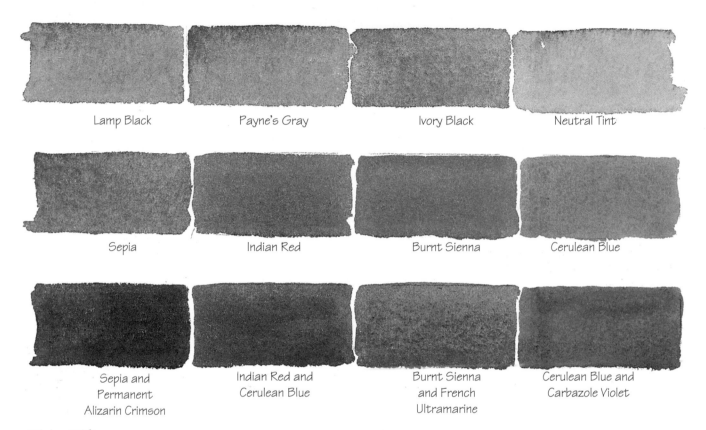

Lamp Black	Payne's Gray	Ivory Black	Neutral Tint
Sepia	Indian Red	Burnt Sienna	Cerulean Blue
Sepia and Permanent Alizarin Crimson	Indian Red and Cerulean Blue	Burnt Sienna and French Ultramarine	Cerulean Blue and Carbazole Violet

Mixing Midtones

All grays are midtones. Each color also has a midtone. The richest midtones are mixed with two or more colors. Notice the subtle variety in color and value when just two colors are mixed to create midtones.

Attract Attention With Shadow
There will be contrast when your shadows are two (or more) steps darker on the value scale. When you have contrast you have painted light!

 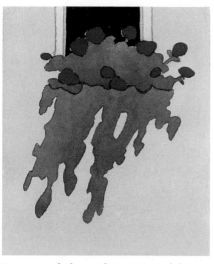

Don't make the mistake of painting shadows with Payne's Gray or any other tube gray. Gray shadows don't relate to the surface on which they are cast unless the local color is also gray. The shadow in this example seems to relate more to the windowpane than to the wall on which it is cast.

The shadow in this example is barely dark enough to read as a shadow. If you looked at this shadow from a distance of ten feet it would disappear!

By using a darker, richer version of the local color your shadows will be convincing. They will relate to the surface on which they are cast, and the feeling of light will be intensified.

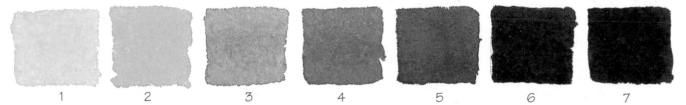

The local color in the above examples falls at no. 2 on the value scale. (This value scale was created by diluting Burnt Sienna with water to make the tints and adding Neutral Tint to make the darker shades.) The shadow color of the above right piece falls around no. 5. Make your shadows convincing by making sure your shadow is two or more value steps above the local color of the surface it is cast on.

Surface Texture and Light

Light, when it falls on a surface texture, exaggerates that texture. When sunlight falls on a stucco wall, for instance, light hits the "hills," and the "valleys" are filled with shadow. It is possible to imitate the textures of rocks, sand, bricks, stucco and tree bark using three simple watercolor techniques. (Cerulean Blue, Indian Red and Burnt Sienna are used in the following examples.)

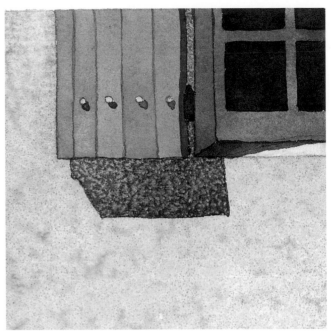

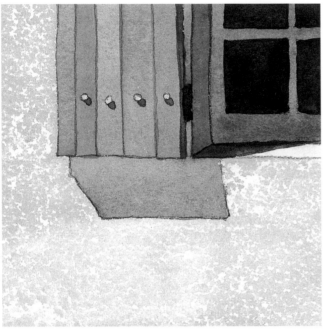

Natural Texture

Granulation occurs when sedimentary pigments are used. Sedimentary colors are paints made with heavier, coarser organic materials. Burnt Sienna, Indian Red, French Ultramarine, Cobalt Blue and Cerulean Blue are sedimentary colors that granulate well. The particles of pigment in those paints settle into the "valleys" of the paper. When you apply a wash using these colors, let it dry without adding to or manipulating it, so the particles of pigment settle and create texture. This process works best on rough or cold-press paper, where paint and paper work together to create a natural texture.

Wax Crayon

Preserve sparkling whites by rubbing a white wax crayon over the surface of the paper before a wash is applied. The waxed "hills" resists the paint and remain white. The paint settles in the "valleys" and the contrast between the two creates a convincing stucco texture.

You can partially remove the wax when the painting is finished and dry. Cover the painting with a clean, absorbent paper towel and press it with a medium-cool iron. Most, but not all, of the wax will be removed.

Sprinkling Salt

Common table salt sprinkled on a watercolor wash produces a variety of textures, from large, soft patterns to small, sharp crystal-shaped patterns. Each grain of salt acts like a sponge and absorbs the liquid and pigment particles.

The perfect time to sprinkle salt is somewhere between wet and damp. Practice and experience will guide you. Experiment with kosher, margarita or sea salt. They each produce slightly different textures.

When your painting is dry, remove the salt by skimming the surface of the paper with the edge of an old credit card.

Exercise Two
Painting Sunlight and Shadows

Try using the salting technique with your watercolor to produce the natural texture of a bumpy wall filled with light and shadow.

Paper
Arches 300-lb. (640gsm) cold-press
 watercolor paper

Palette
Indian Red
Burnt Sienna
Cerulean Blue
Winsor Red
Winsor Green (Blue Shade)

Brushes
Round: no. 8 and no. 10

Other
No. 2 pencil
Table salt

Step 1: Pencil Sketch
Draw this image on your water-color paper.

Step 2: Paint a Stucco Wall in Sunlight
Mix a pale wash using Indian Red, Burnt Sienna and Cerulean Blue. Use a no.10 round brush and lay this wash over the area in direct sunlight. As the wash begins to dry slightly, sprinkle table salt over the wash. Put this aside on a flat surface and let it dry completely. Remove the salt by scraping the edge of an old credit card across the surface of the paper. Feel the surface of the paper with your fingertips to make sure you've removed every grain of salt.

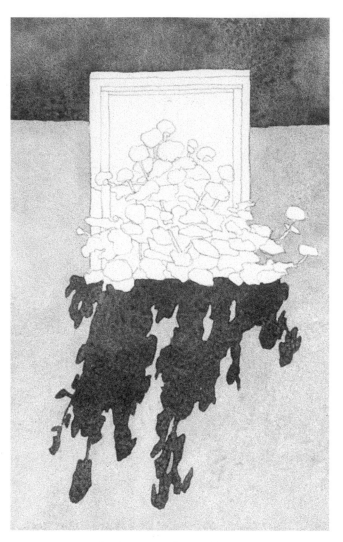

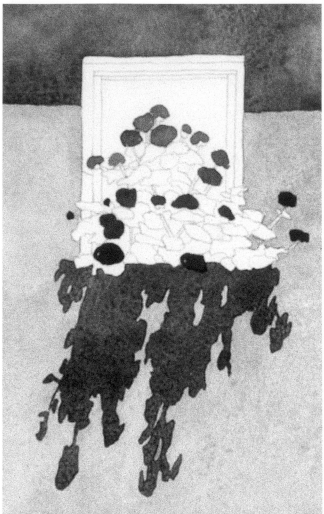

Step 3: Paint Shadows on the Wall

The salt technique left a pattern of light and dark that creates the texture in step two of this exercise. Find the darkest piece of this textured pattern and mix a shadow color that matches. Make sure it is at least two value steps darker than the wall color.

Use a no. 10 round brush and paint a dark concentration of Burnt Sienna, Cerulean Blue and Indian Red in the shadows. Vary the color slightly from blue to red as the plant's shadow gets farther away from the foliage. (Use a touch more Cerulean Blue at the top and a touch more Indian Red at the bottom.) As the shadow washes dry slightly, sprinkle salt into them. Set the painting aside on a flat surface and let it dry completely. Remove the salt.

Step 4: Paint the Flowers

Establish where the flowers are going to be in the early stages of the painting. The space behind the foliage will be very dark to create a strong contrast with the Winsor Red flowers. Do not paint all the flowers at full saturation, but add water to make the top flowers a lighter red. Notice that the flowers become darker the lower they are.

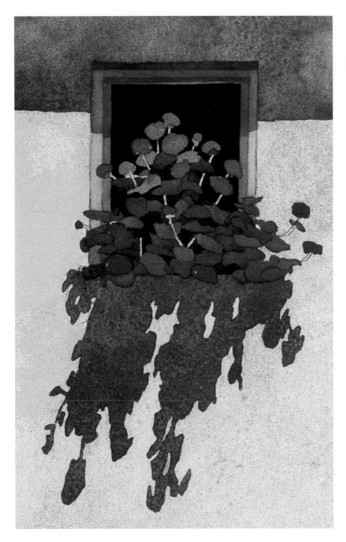

Judy Morris NWS

Step 5: Paint the Leaves

Mix Winsor Green (Blue Shade) with Burnt Sienna for your greens. Paint the lightest greens toward the top where light would fall. By keeping the foliage near the top lighter, you will also emphasize the contrast you create when you paint the dark space of the window.

Use a no. 8 round brush and paint the window the palest tint of Cerulean Blue where light hits the window frame. Gradually darken the Cerulean Blue by using less water and adding a touch of Indian Red because the frame is in the shadow. Finish the window frame with darker shades of Cerulean Blue. Mix Winsor Red, Winsor Green (Blue Shade) and a touch of Cerulean Blue to make a dark and paint the window.

Step 6: Final Touches

Finish the painting by adding some definition to the flowers with Winsor Red, using a no. 8 round brush. Fill in the stems with Burnt Sienna and adjust the color of the window frame if necessary. I discovered my window frame was too dark, and there was no contrast between it and the stucco wall. So I used white latex paint mixed with just a touch of Cerulean Blue and painted over the window frame, making it lighter in value. You may want to darken the shadow just under the foliage to give the feeling of more depth. Now you can sign your name!

One O'Clock Shadow
13" × 9" (33cm × 23cm)

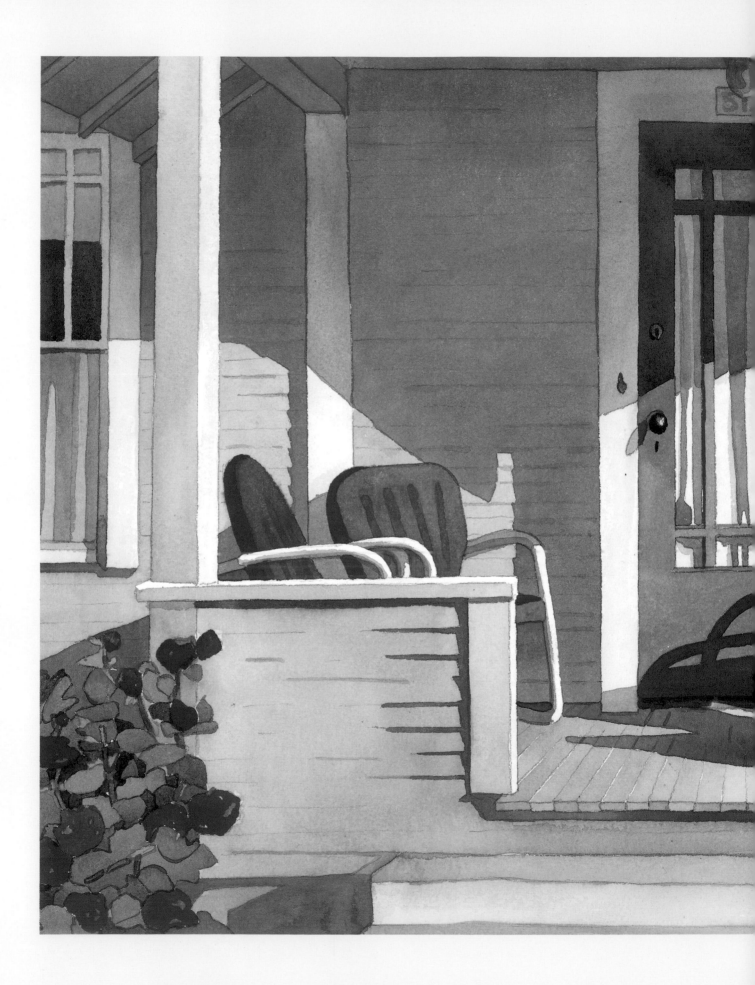

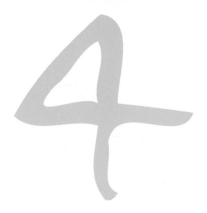

GETTING TO KNOW
YOUR LIGHT SOURCE

Occasionally light presents the perfect shadow that results in a spectacular painting. However, most successful paintings don't happen by chance. Light has to be manipulated by shifting the source direction, varying the kinds of light, altering the shadow direction or adding highlights that accentuate the strength of the light. Shadows might need to be modified to transform ordinary objects into exciting subjects to paint. Exaggerating light can help define form and enhance design.

Hard work goes into every painting! When you understand your light source and know how to control and maneuver it, your paintings will look like they happened effortlessly and easily. The viewer will think the subject was there by chance.

Pat & Olie's
13½" × 17½" (34cm × 44cm)

Light Direction

The position of the light source determines the form of the object upon which the light falls. Lights, darks and shadows change when the light source changes position. Knowing the characteristics of front, side and back light can help you let light reveal the form best suited for your paintings.

Front Light
When the light source is in front of an object, details are flattened and texture and form seem to disappear. Lights and darks are reduced to a minimum. Shadows fall behind the object and are usually quite small, insignificant and not very dramatic.

Side Light
Lights, darks and textures are exaggerated when the light source is at the side. Shadows are dramatic and create strong patterns. Side light reveals form and depth in the most descriptive way because contrasts are exaggerated.

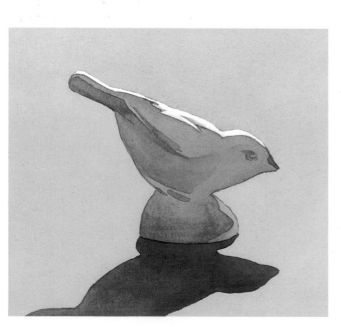

Back Light
Back light also simplifies the textures and values because most of the object is in the shade. The very light areas will be found only around the outline of the object. The details will be vague and less noticeable. The shadow becomes an important shape in the foreground.

Natural Light

The sun and moon are sources for natural light. The kind of light they produce varies from bright sunlight directly overhead on a clear day to just the barest hint of light coming from the sliver of the crescent of a new moon.

You can also make use of natural light indoors. Many artists plan a studio where the windows face north and provide clear and consistent light. (In the southern hemisphere the windows would be placed to the south.) North light allows you to paint throughout the day without worrying about the light changing.

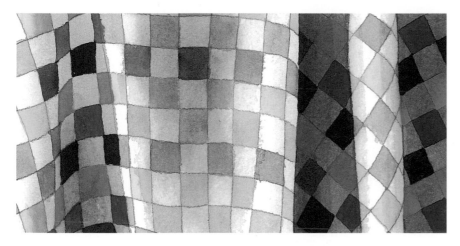

Sunlit Colors
Create the feeling of intense sunlight by putting your richest colors in the shadows and painting lighter values of the same color when they are in the direct sunlight.

Sunlight
The main light source for outdoor painting is the sun. When the light from the sun is bright and crystal clear, there is a precise distinction between the object it falls on and the shadow it creates. The edges of the shadows are clear and crisp. But bright sunlight also washes out color. Colors will be weak on the surfaces where the light falls and rich in the shadows. Compare the intensity of red in the sunlight and in the shadows of the tablecloth.

The Picnic
18" × 20"
(46cm × 51cm)

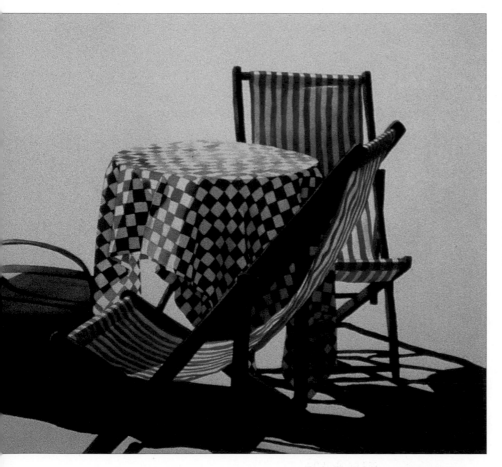

Natural Light

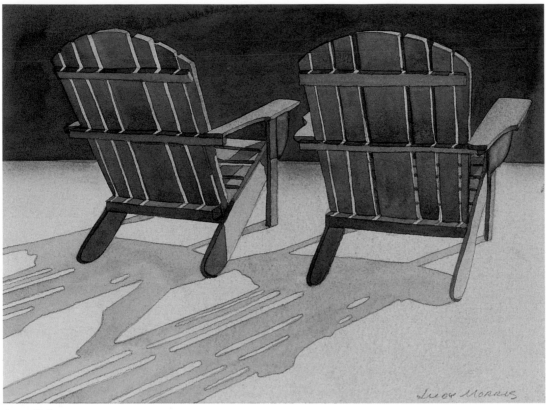

Moonlight
Light from the moon is not nearly as bright as light from the sun—but it *can* cast shadows! There is less contrast between the subject and the shadows in moonlight than sunlight, and all the colors in the painting will have a cool undertone.

Moonglow Colors
Create convincing "moonglow" colors by underpainting the entire paper with a pale wash of Indian Red and Carbazole Violet. If the moon is in your composition, use a damp sponge and a circle stencil to remove some, but not all, of the wash in that area. Keep your other colors close in value but slightly different in hue.

Artificial Light

If you want complete control over the way light falls on the subjects you paint, paint indoors under artificial lights. You will be able to adjust the intensity, direction and even the color of the light. You can create dramatic still-life arrangements and the light won't move and change the shadows!

If you paint indoors, use daylight-simulation bulbs or fluorescent strip-lighting that imitates natural daylight. The colors you use when you paint will look the same as they would look in natural light.

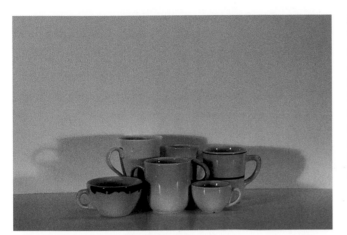

Low-Contrast Indoor Light
When light comes from many directions, no strong contrasts or shadows exist. Artificial lights directed on this arrangement of white cups came equally from the right side, the left side and directly above. This type of artificial light illuminates nearly all the surfaces equally and neutralizes shadows. Use this type of artificial lighting when you want diffused shadows and highlights.

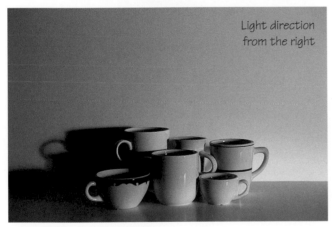

Light direction from the right

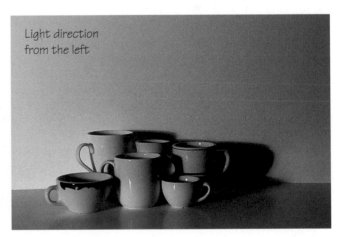

Light direction from the left

High-Contrast Indoor Light
When the primary source of artificial light comes from a single direction, the contrasts and shadows are intensified. Form is more clearly revealed as shadows move across surfaces. Light from a single source adds more drama to a composition. The focus of a still-life arrangement changes depending on whether the light comes from the left or the right. Experiment with artificial light placement to find shadows and highlights that will be an asset to your painting.

Reflected Light

The ability to see and capture reflected light not only brings luminosity to your paintings but adds color harmony as well. Almost every surface (but not black velvet!) reflects colored light to some degree. The color of the reflected light depends on the surface colors surrounding the objects you are painting. If you are painting outside on a clear, sunny day, blue from the sky or the greens from surrounding foliage will be reflected in the shadows of the objects you are painting. If you are painting indoors, the colors from surrounding objects will be reflected in the shadows.

Different surfaces reflect light differently. White or colored objects reflect light differently from shiny or clear objects. Learn to see reflected light by placing a variety of different objects on colored pieces of fabric. You will be surprised how much reflected light you will see!

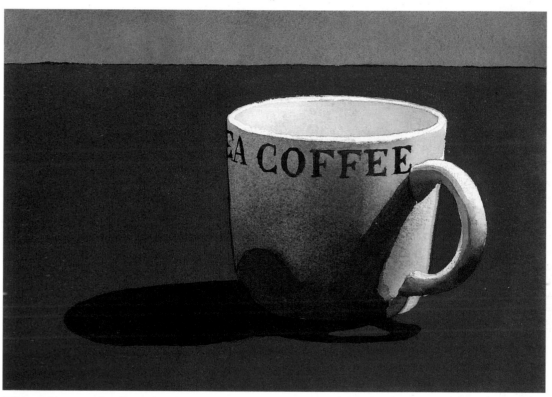

White Objects and Reflected Light
This white cup reflects the red light from the fabric it is sitting on and the blue light from the sky above. The most intense reds are found in the darkest shadows. Notice how the blue from the sky is reflected on only the top surfaces of the handle and on the left side of the cup. There is no red reflected inside the cup because the inside of the cup gets reflected light only from the blue sky above. Painting the letters shades of dark red instead of black intensifies the feeling of reflected light. The shadow is painted a solid, dark shade of red.

Shiny Objects and Reflected Light

Shiny objects reflect the most light! This painting of a silver cup proves silver is a "shine" and not a "color," and the form is defined only by the lights, darks and colors it reflects. The main body of the cup is red but the red of the cup is not as intense as the surface it is sitting on. Notice the blue reflected on the top surfaces of the handle and the filigree surrounding the lip. Red is reflected on the bottom surfaces. Again, no red is reflected inside the cup because the inside of the cup gets reflected light only from the blue sky above it. The shadow is also a solid, darker shade of red.

Clear Objects and Reflected Light

The form of clear objects is defined more from the reflected color above than from the surface on which it is sitting. The red surface is seen through the clear glass of the cup and remains intense. Slight variations of red add sparkle to the glass. Blue reflected from the sky, white highlights and a few darks define the rest of the cup. The shadow of a clear object is not solid! Light shines through the glass and creates a pattern of light and dark shapes that echo the feeling of transparency.

Exercise One
Painting Reflected Light

Three birdhouses hanging together present interesting shapes, especially when they are painted colorful hues. The shadow, because of the light source, becomes the shape that ties the composition together. Painting the colorful birdhouses, with the shadow cast on the stucco wall, offers the perfect opportunity to paint reflected light.

Paper
Arches 300-lb. (640gsm) cold-press
 watercolor paper

Palette
Burnt Sienna
Cobalt Blue
Yellow Ochre
Winsor Red
Morris Black

Brushes
Round: no. 6, no. 8, no. 10 and
 no. 12

Other
No. 2 pencil
Kosher salt

Step 1: Pencil Sketch
Draw this sketch on your watercolor paper.

**Step 2: Salt Texture
in the Sunlight**
Mix Burnt Sienna, Cobalt Blue and Yellow Ochre with lots of water to make a pale wash. Brush this wash over the area of sunlit stucco with a no. 12 round brush. As this wash starts to soak into the paper, sprinkle kosher salt on the surface. You may want to leave a few "skips" (small areas of unpainted paper) that will become heavier textured stucco when shadows are added. Let the wash dry completely before removing the salt.

Step 3: Adding the Shadow

Mix a darker shade of the stucco color for the shadows. Use a no. 12 round brush and paint the shadow at the top this darker shade. Sprinkle kosher salt over the surface to create the stucco texture.

Start at the lower edge of the shadow under the birdhouses and paint using the same shadow color with your no. 12 brush. When you get closer to the birdhouses, gradually add Winsor Red to the shadow color and paint that mixture under the birdhouse on the left. Add Cobalt Blue to the shadow color as you paint under the middle birdhouse, and add Burnt Sienna, with a little Winsor Red added for richness, to the shadow color under the birdhouse on the right. Sprinkle kosher salt on the shadow color to create the texture of stucco. You've just painted reflected light! Use a no. 6 round brush and the darker mixture of local color and paint small shadows under the "skips" in the sunlit stucco. Let it dry. Remove the salt.

Step 4: Paint the Birdhouses

Use a no. 8 round brush and paint the birdhouses Winsor Red, Cobalt Blue and Burnt Sienna. Paint the colors most intensely in the shadows. Add a small amount of Yellow Ochre and water to lower the intensity and value of all three colors where they are in direct sunlight. Show the reflective light on each birdhouse, using some Cobalt Blue on the red house, some Burnt Sienna on the blue house and some Winsor Red on the yellow house to reflect the warmth of the wall.

Step 5: Add Details and Background

Paint the rectangular shape on the left with Morris Black and a no. 10 round brush. Create interest by painting a small horizontal rectangular shape near the top a mixture of Morris Black and Winsor Red. This shape represents part of a window frame. Fill in the birdhouse entrance holes with Morris Black and a no. 8 round brush. Mix Cobalt Blue, Winsor Red and Yellow Ochre to get a light and dark shade of gray. Use these grays and a no. 6 round brush and paint the light and dark parts of the hook on the blue birdhouse, and the light and dark parts of the screw eyes on the red and yellow birdhouses. Paint the strings the birdhouses are hanging from in this same manner. Use your no. 6 brush and a little opaque white paint to clean up the edges of the string if necessary.

Fly Home
18" × 13" (46cm × 33cm)

Focused Light

Pretend you are a camera. You zero in on a paintable subject. The focus dial is manipulated until what is seen in the viewfinder is in perfect focus! The edges are sharp and clear. There is a perfect separation between adjacent shapes. Nothing is fuzzy. This is the way many artists see and paint the world.

The most notable characteristic of focused-light paintings is hard edges. Focused-light paintings are more methodical in approach, and colors and values of superimposed washes are applied with a wet-on-dry technique.

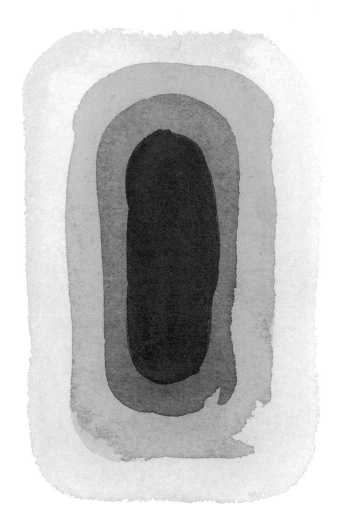

Wet-on-Dry Technique
Painting wet-on-dry allows you to control the edges of your washes. Edges stay crisp and fresh because each wash is allowed to dry before the next wash is applied. If a series of transparent layers are overlapped, each layer must dry completely before the next layer is applied.

Hard Edges
Catching focused light results in paintings with hard edges. Shapes and colors are clearly defined. Washes are controlled, and colors in one shape are not allowed to mingle with colors in an adjacent shape.

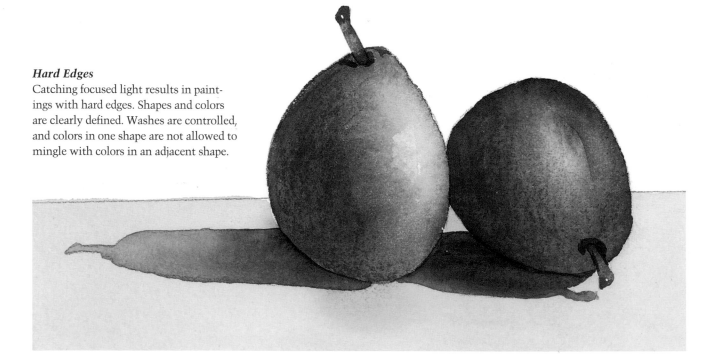

Diffused Light

You are still a camera, only now you see the world slightly out of focus. Edges are soft and subtle. Diffused light defines edges with a gentle suggestion rather than a literal description.

Painting diffused light gives the artist the opportunity to let colors flow together. The element of chance created by using the wet-in-wet technique produces soft, hazy edges between the painted shapes.

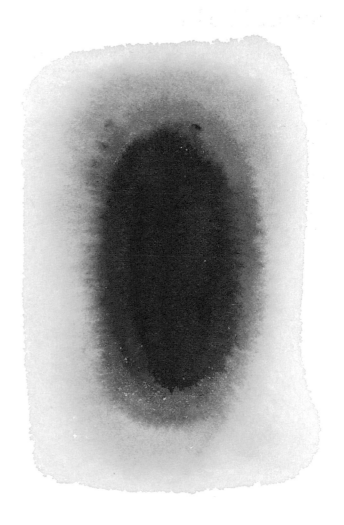

Wet-in-Wet Technique
Soft edges can also be created when the paint in one shape or area is not allowed to dry thoroughly before the adjacent shape or area is painted. The colors flow into each other. This flow can be subtle or pronounced depending on the desired effect. It takes practice and experience to control the spontaneous behavior of wet-in-wet painting.

Soft Edges
Cottony, delicate edges give the illusion of diffused light. Colors in adjacent shapes are allowed to slightly mix and mingle. An element of chance is ever present! The artist must keep alert and guide the paint where it is wanted.

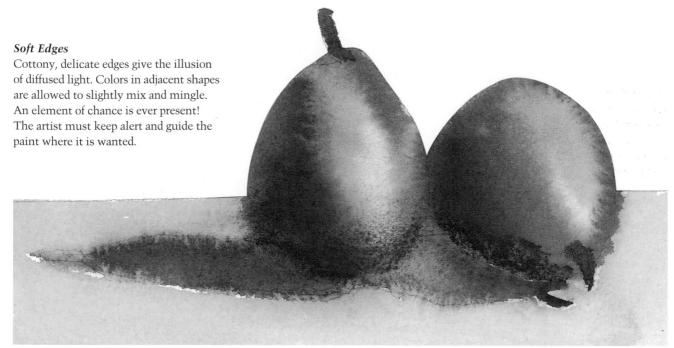

Exercise Two
Painting Focused And Diffused Light

"Soft" is easy to feel and see. "Soft" is a little harder to paint! Light coming from behind creates a halo of "softness" around this cat. The dark background accentuates the diffused light. The sharp edges of the chair and flowers heighten the contrast between soft and sharp. Follow these steps to practice painting focused and diffused light.

Paper
Arches 300-lb. (640gsm) cold-press
 watercolor paper

Palette
Yellow Ochre
Cerulean Blue
Winsor Green (Blue Shade)
Burnt Sienna
Sepia
Indian Red
Winsor Red

Brushes
Round: no. 6, no. 8 and no. 10

Other
No. 2 pencil

Step 1: Pencil Sketch
Draw this image onto your watercolor paper. Indicate the edge of the cat's fur with very sketchy marks so the pencil doesn't show through the paint later on.

Step 2: Painting the Base for a Soft Edge
The back light shining through the cat's fur offers the perfect opportunity to paint a soft edge. Use Yellow Ochre, clear water and Cerulean Blue to paint a "halo" around the image of the cat. Use a no. 8 round brush and paint Yellow Ochre on the outside edge, closest to the light source. Use the same brush and paint the middle with clear water. Gradually add Cerulean Blue to the water, making the edge away from the light source blue. These washes create the soft edge of the cat's fur.

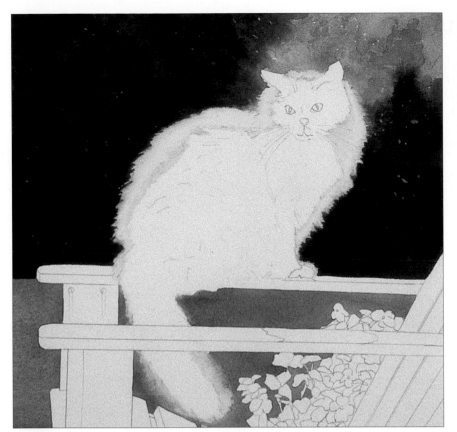

Step 3: Wet-in-Wet Background

Mix a variety of greens using Winsor Green (Blue Shade), Burnt Sienna and Cerulean Blue, and paint in the background using the wet-in-wet technique with a no. 10 round brush. Use more Cerulean Blue above the cat's head to represent sky. Lighten the greens by adding more water and paint the lawn behind the chair.

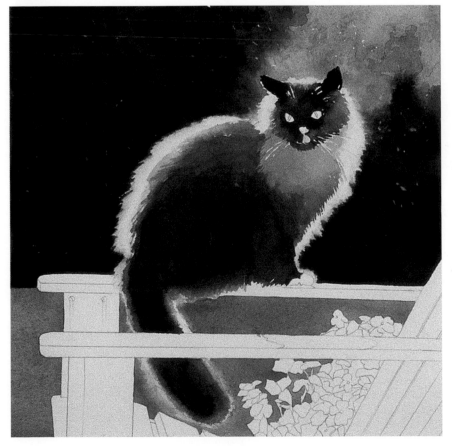

Step 4: Paint the Cat's Fur

Work quickly using a variety of light and dark browns mixed from Sepia, Yellow Ochre, Cerulean Blue and Indian Red to paint the cat's fur with a no. 8 round brush. Start with the darkest mixture and paint the ears. Work down from his face, letting the puff of fur directly below his chin dry so you get a clear definition between the two fur areas.

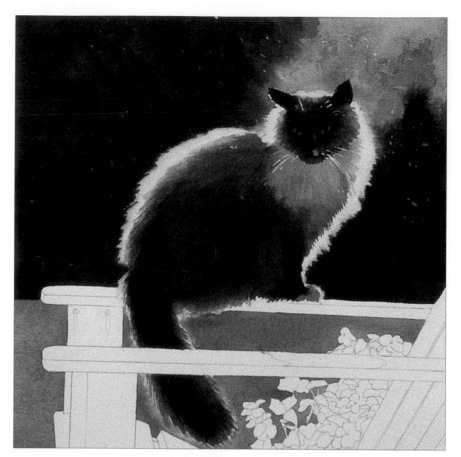

Step 5: Fur and Face Details

Use your no. 8 round brush and add detail to the fur by painting soft, feathery brushstrokes in the natural direction the fur grows, using a slightly darker color than the base coat. Add face detail and eye color using variations of the colors from step two and the no. 8 brush.

Step 6: Painting the Chair

Paint the chair using the wet-on-dry technique to keep edges crisp and in sharp focus. The arms and the slats in the seat of the chair are in the direct sun and will reflect color from the sky. Mix a light brown, with definite Cerulean Blue undertones, and paint those areas with your no. 8 round brush. The rest of the chair is in the shade. Mix three shades of dark brown and paint the shapes in the shade with the no. 8 brush. Remember to let each shape dry completely before painting the adjacent shape. You may want to use a hair dryer on a low setting to hurry along the drying process.

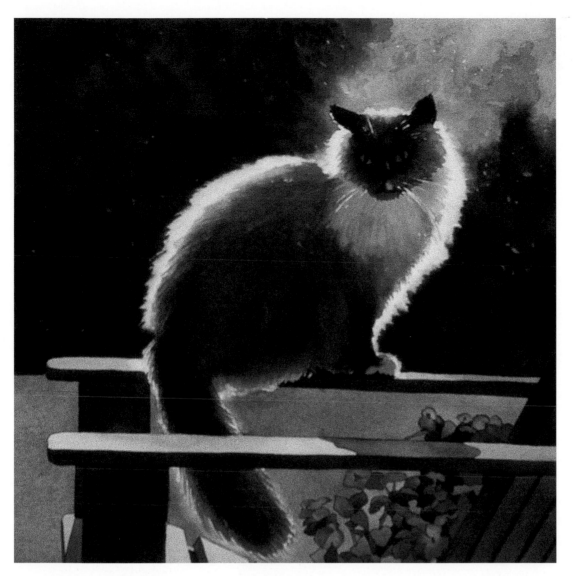

Step 7: Flowers and Foliage

Use a no. 6 round brush and tints and shades of Winsor Red and paint the flowers. Mix greens for the foliage by using Winsor Green (Blue Shade) and Burnt Sienna. Paint in the greens with your no. 6 brush. The sharp, crisp edges of the chair and flowers make a nice contrast with the soft, cottony edges around the cat and the greens that mingle together in the background.

Willie on His Chair
13" × 13" (33cm × 33cm)

Light Defines Form

Light falling across an object creates value contrasts that help define the form of that object. When light falls across spherical or smooth objects the changes in value are gradual and graduated to give the impression of roundness. When light falls across objects full of planes and angles the changes in value are sharp and precise. Light falling across an object and the resulting shadows are the "key" that unlocks the visual suggestion of volume and form.

Sharp Angles and Planes

Two photographs of this doll-size Adirondack chair are excellent examples of how light helps define objects with sharp angles and planes. When there is no obvious light source the range of values is limited (left) and, though the shape of the chair is visible, it is not as clearly defined as it is with directed light (right). The wet-on-dry technique works best when you are painting objects with distinct angles and planes.

Round and Smooth Surfaces

There are no sharp edges and angles when directed light falls across round and smooth surfaces. The value changes are gradual and soft and can be rendered best by using the wet-in-wet technique. Careful observation of the way light falls across forms is crucial to visually describing the objects you paint. The kind of edge (sharp or soft) that light creates defines form.

Light and Shadow

Light Source and Shadow Direction

When painting light the significance of shadows cannot be ignored. Without shadows, whether they are strong or subtle, painting light would be impossible. Understanding and painting shadows is the single most powerful way to suggest the feeling of light.

You must paint believable shadows. It is easy to do when you paint indoors using an artificial light source because the shadow doesn't move! Painting on location is a different story. The sun moves and so do the shadows. You have to be quick in capturing the shadows that suggest the feeling of light. Don't be discouraged by a moving shadow. An easy method of making sure cast shadows are consistent with the light source is to use parallel lines to mark the long edges of the shadow shapes.

Shadows on a Wall
Use parallel lines drawn at a 45-degree angle for a shadow that is cast on a vertical wall in the mid-afternoon sun. The long edges of the shadow are consistent because they are parallel.

Shadows on the Ground
Shadows at the end of the day are long and exaggerated. Use long, horizontal parallel lines to establish a guide for the edges of the shadow shape.

Light and Shadow

Shadows Anchor Objects

Whether you are painting a landscape on location or a still life in your studio, shadows anchor your subject to the surface on which it is placed. The shadow of a tree, for instance, helps describe the contours in the field of grass on which it is growing. The shadow created by light falling across a still life defines the table top on which it is placed. The main function of a shadow is to anchor the object and give it solidity.

Shadows Reveal Light

Shadows are tricky! As shadows move across the landscape they hide and reveal light. The same subject can take on a completely different personality depending on the movement of shadows. An ordinary scene is suddenly stunning, prompting you to think "Where did that come from?"

In the Shade
This garden scene is mostly in the shade. The few light areas scattered in the background evoke the feeling of light, but nothing in particular stands out as subject matter for a painting.

When the Shade Moves
The shadow moved and light appeared! The rose bushes are bathed in light and could become the focus for an intriguing painting.

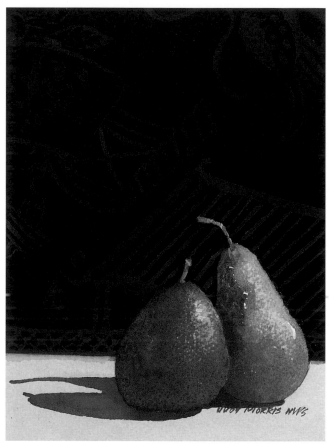

Shadow Information
The simplest way to give an object the feeling of solidity is by adding a shadow. The shadow from the pears not only indicates that the light source comes from the right, but it tells the viewer that the surface the pears are sitting on is flat.

A Pair
9" × 6½" (23cm × 17cm)

Shadows and Time of Day

Light from the sun reveals subjects to paint from sunrise to sunset. Every hour of the day has its own unique light that produces shadows and colors relative to that time. Geographic location, the seasons and weather conditions also influence light, but the time of day remains the dominant factor in determining the shape of the shadows. The timing in finding the right light is all-important.

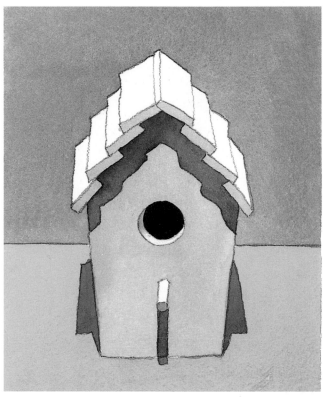

Morning or Evening Shadows
Because the sun is lower in the sky in the early morning or late afternoon, shadows are stretched and become longer and more dramatic. If dramatic shadows appeal to you, search for subjects to paint early or late in the day.

Midday Shadows
Light during the middle of the day is more directly overhead, and midday shadows fall directly under objects. The shadows are smaller, but not necessarily less important than shadows found at other times during the day.

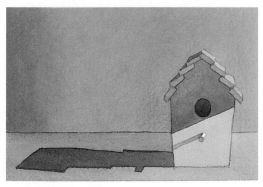
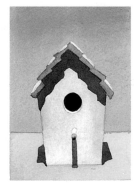
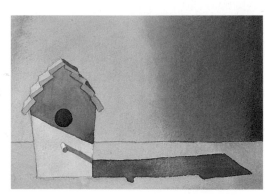

The Color of Light
As the sun moves across the sky from dawn until dusk shadows are not the only aspect of light that changes: The color of light changes in subtle but distinct ways as well. The early light of dawn begins with soft, clear colors ranging from violet to blue-greens. As the hours march on the color of light gets brighter and more harsh until midday when contrasts are the strongest. Gradually the softness returns with golden grays in the late afternoon. Sunsets may come alive with rich blues and violets and deep crimson.

Monet, on a quest for perfect light, once surveyed the countryside, looked at the sun and then at his watch and said, "I'm half an hour late. I'll come back tomorrow."

Exercise Three
Light Transforms Ordinary Objects

We look at the "ordinary" and we see "ordinary." Magic happens and light transforms what we thought was ordinary into something that *has* to be painted.

An Ordinary Tablecloth
This photograph of a crocheted table-cloth shows little variation in lights and darks. Make it extraordinary by exaggerating the contrasts.

Paper
Arches 300-lb. (640gsm) cold-press
 watercolor paper

Palette
Indian Red
Cerulean Blue
Yellow Ochre

Brushes
Round: no. 10 and no. 6

Other
No. 2 pencil

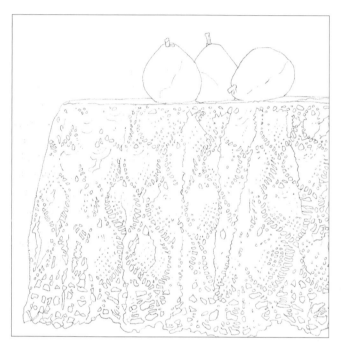

Step 1: Pencil Sketch
Draw this image onto your watercolor paper.

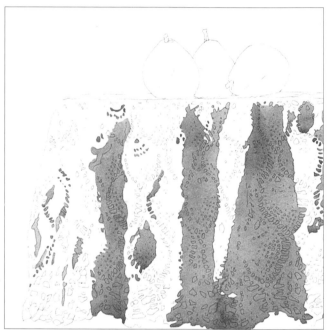

Step 2: Paint the Shadows
Mix Indian Red, Cerulean Blue and Yellow Ochre to make a colorful gray. Paint the areas of the tablecloth that are in shadow with this mixture using a no.10 round brush.

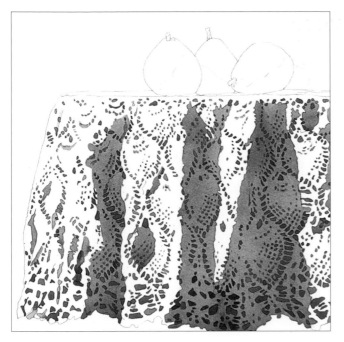

Step 3: Paint the Crochet Pattern
Use more pigment and less water to mix darker shades of yellow, red and blue and fill in the design of the crocheted tablecloth using a no. 6 round brush. It is not necessary to make every "hole" but paint repeated dark shapes that mimic the pineapple pattern of the crochet. Vary your darks by using more Indian Red in some, more Cerulean Blue or Yellow Ochre in others.

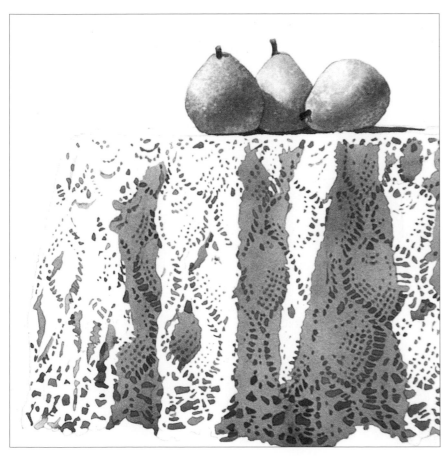

Step 4: Paint the Pears
Use the salt technique to imitate the surface texture of the pears. Mix your three colors into a variety of yellows and greens. Use the no. 6 round brush and paint the lightest yellows where the light falls across the pears; paint your darkest greens in the shadow areas. Pay attention to reflected light by adding more yellow to show the light bouncing off the other pears and the table.

Step 5: Paint the Background

A dark background is desirable to showcase the light falling across the tablecloth and pears. A pattern is more interesting than a plain wash. Draw a pattern, getting your inspiration from fabric or wallpaper (or invent your own pattern). Mix Yellow Ochre, Indian Red and Cerulean Blue to make two dark grays, one with pronounced red tones and the other with more blue tones. Use a no. 6 round brush and paint the negative part of the pattern with a mixture of dark gray with a pronounced blue undertone.

Step 6: Final Touches

Paint the positive shapes of the pattern with a no. 6 round brush, using a dark gray mix with pronounced red undertones. Keep the values of the background nearly the same and you will create a background that reads as one dark shape but, upon closer inspection, has an interesting pattern.

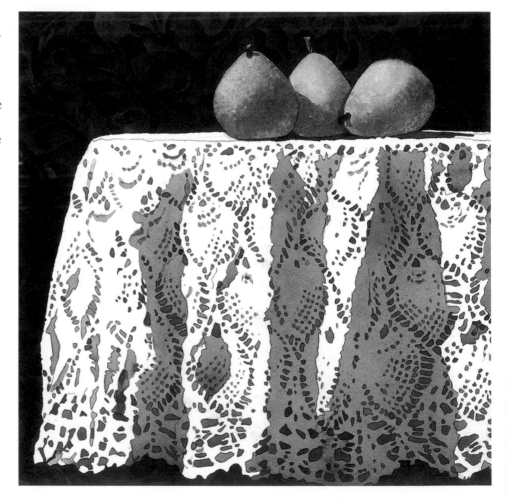

Pears and Lace
13" × 13" (33cm × 33cm)

Enhance the Illusion of Light

Shadow patterns are intriguing, to say the least. When the light is just right, commonplace subjects are transformed and that is when they are noticed! Sometimes the light is not quite strong enough to really catch attention. That is the time when the illusion of light must be enhanced.

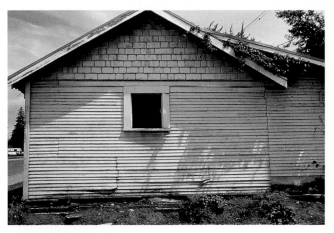

Weak Shadow Pattern
The back of this garage is not very exciting. But it is interesting because the dark, square window contrasts with the light color and the horizontal lines of the siding. The shape of the shadow is appealing but too weak.

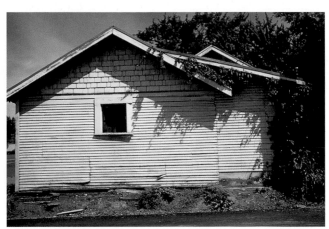

Strong Shadow Pattern
On a different day it looks like this. The shadow is the first thing that is noticed! The sun was brighter this day and the light fell across the vine and roof line creating a darker, bolder shadow. The darker shadow gets attention!

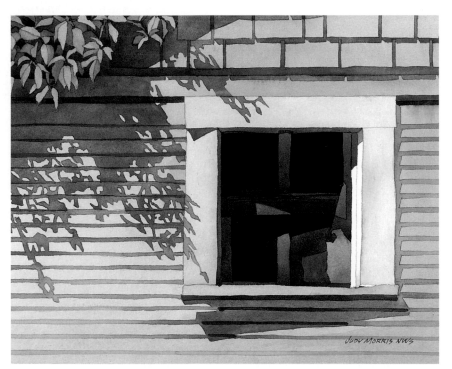

Enhancing Light
The initial contrast of the square window and the horizontal siding is still there. The illusion of strong sunlight is enhanced by painting the shadow darker and bolder. It is always a good idea to put a little bit of what caused the shadow in a composition. Just a hint of vine leaves in the top left corner makes the shadow believable because it tells where the shadow came from.

10th Street Garage
10½" × 13½" (27cm × 34cm)

Exercise Four
Underpaint to Exaggerate Light

If you know you are going to paint something white, and you know that object is going to be in the direct sunlight, you can underpaint to exaggerate that light. Reserve the white by painting around it, using masking tape or using a masking fluid. Brush a pale wash over the rest of the paper. By doing this, you have eliminated any competition for light! Everything else in the painting will be at least one shade darker than the reserved white. (Underpainting also creates color harmony. A bonus!)

Paper
Arches 300-lb. (640gsm) cold-press
 watercolor paper

Palette
Burnt Sienna
French Ultramarine
Indian Red

Brushes
Round: no. 12 and no. 8

Other
No. 2 pencil
Winsor & Newton Colourless Art
 Masking Fluid

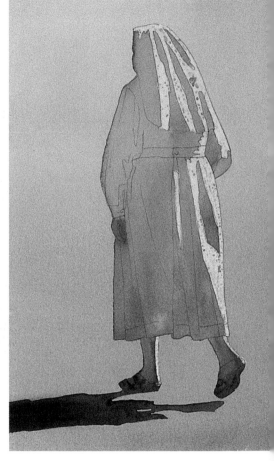

Step 1: Sketch and Mask
Draw this image onto your watercolor paper. Reserve the whites by applying a liquid mask. Let the mask dry completely.

Step 2: Underpaint
Use a no. 12 round brush and apply a pale wash of Burnt Sienna mixed with French Ultramarine over the whole paper. Allow more Burnt Sienna at the top and more French Ultramarine at the bottom. Let it dry.

Step 3: Paint Midtones
Mix Burnt Sienna, French Ultramarine and Indian Red together to paint the midtones found in the garment with a no. 8 round brush. Fuse a little more Burnt Sienna on the face, hand and legs for warm flesh tones. Mix a darker value of the three-color wash and paint the shoes and shadow.

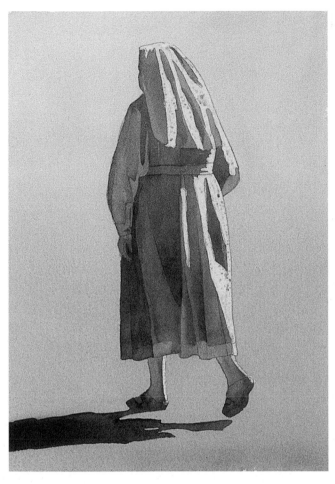

Step 4: Details

Use a no. 8 round brush and define the darker folds of the cloth with a darker mixture of your three colors. Adjust the flesh areas with a mixture of Burnt Sienna and Indian Red. Let it dry.

Step 5: Remove the Mask

Use your fingertips or a soft eraser to remove the liquid mask. The whites will sparkle with bright light!

In the Sun
13" × 9" (33cm × 23cm)

Exercise Five
Highlights Accentuate Light

You do not have to cover every inch of your watercolor paper with paint. In fact, you will want to leave areas of pure white paper because those whites will give the impression of sunlight glancing off the objects you are painting. The whites you leave (or add with body color if necessary) add sparkle and accentuate the presence of light.

Paper
Arches 300-lb. (640gsm) cold-press
 watercolor paper

Palette
Indian Red
Cerulean Blue
Burnt Sienna
Winsor Green (Blue Shade)
Winsor Red
Morris Black

Brushes
Round: no. 10, no. 8 and no. 6

Other
No. 2 pencil
White latex flat wall paint

Step 1: Pencil Sketch
Draw the amaryllis onto your watercolor paper.

Step 2: Painting the Petals
Use a pale washes of Indian Red, Cerulean Blue and Burnt Sienna to paint the petals of the amaryllis with a no. 10 round brush. Make the petals look transparent using the wet-on-dry technique, painting one petal and letting it dry completely before overlapping a wash to paint the adjacent petal. The color will be darker where the washes overlap. Instant transparency! Fuse Winsor Green (Blue Shade) into the "neck" of the flower and Winsor Red into some of the darker shapes. Mix Winsor Green (Blue Shade) with Burnt Sienna for greens to paint the stem with a no. 8 round brush. Leave highlights of white paper on the flower on the right. Highlights should be irregular in shape to look natural.

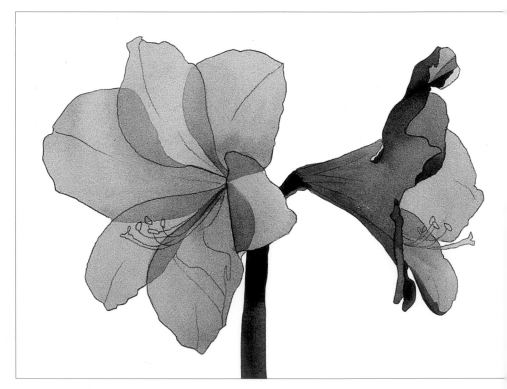

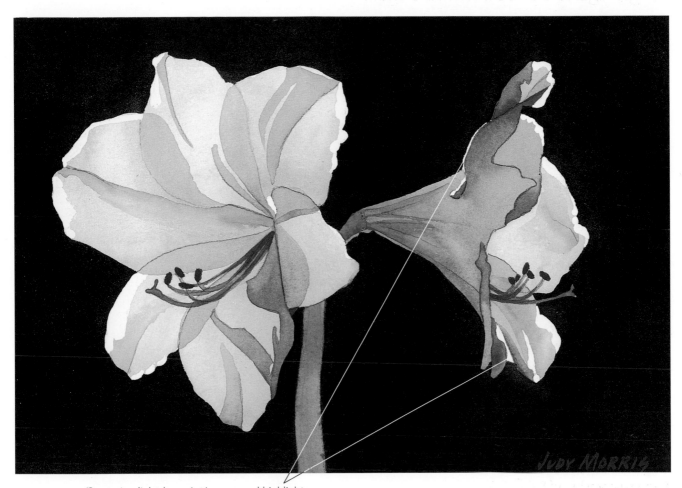

Reserving light by painting around highlights.

Step 3: Highlights and Background

Use a no. 6 round brush and fill in the pistil and stamens with Winsor Red mixed with a little Burnt Sienna. Use a no. 10 round brush and paint the background with Morris Black for the most possible contrast. Fill in more highlights on each blossom with white latex wall paint.

Linda's Present
9" × 13" (23cm × 33cm)

LIGHT SETS THE MOOD

My mood is not always sunny and neither is the weather. Some days I don't find sharp contrasts and shadows with definite edges. Some days mist hovers around the trees and shrubs in my garden and the dominant color of everything is gray. Some days I feel like I need a flashlight just to go to the mailbox! Some days I don't even want to go outside.

Don't stop painting on days like that. Instead, adjust your perspective and palette to fit the mood the available light presents. Work with the quality, quantity and even the absence of light, and not against it. The mood may not always be sunny but it can always be happy!

Along the Kinderdyke
12" × 18" (30cm × 46cm)

High-Key vs. Low-Key Paintings

Every painting will evoke an emotional response from the viewer. That response is triggered by values, colors and contrasts, as well as the quality of light. Paintings that are light in value are called "high-key" paintings and usually evoke airy, delicate, optimistic moods. Paintings dark in value are called "low-key" paintings and summon moods that are mysterious, dramatic or even melancholy. Let light define the mood and emotional impact of your painting by planning the "key" before you start painting.

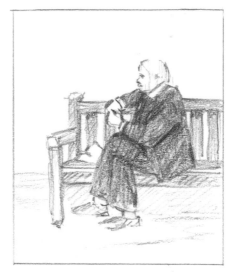

High-Key Value
The "key" of a painting is determined by the dominant value. This sketch features light values and is, therefore, designated high-key.

High-Key Color
Lighten colors with water to make tints and light middle values for high-key color. Choose colors from the light end of the value scale and avoid strong contrasts. Light colors and soft contrasts convey a bright, cheerful mood. Here, tints of Cadmium Yellow, Winsor Green (Blue Shade), Cerulean Blue, Carbazole Violet, Permanent Alizarin Crimson and Indian Red are mingled together.

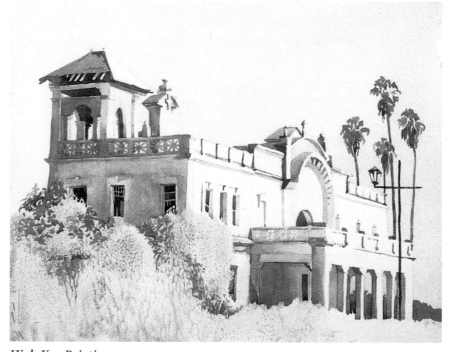

High-Key Painting
The colors and values in this painting are light and bright. Contrast is not sacrificed but it is subtle and soft. Few values are darker than the middle of the value scale, and this soft contrast and subtle color evokes a mood of delicate sunlight.

Chapala Train Station
Jacque Brown
Watercolor
15" × 21" (38cm × 53cm)

Low-Key Value
The values in this sketch are mostly from the dark end of the value scale, making this a low-key sketch.

Low-Key Color
Darker, more somber low-key colors indicate less light and a more pensive mood. Colors range from the middle of the value scale to rich, luxurious darks. Black can be useful in a low-key color scheme. Here, Burnt Sienna, Winsor Red, Indian Red, Sepia, Cobalt Turquoise, Carbazole Violet and Winsor Green (Blue Shade) mingle to form beautiful darks.

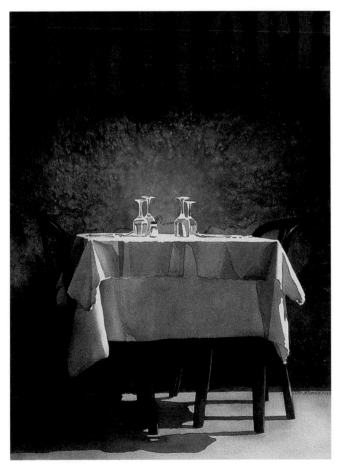

Low-Key Painting
The nostalgic mood of this painting results from using rich, dark colors in more than 50 percent of the surface area. Light falling on the table creates a strong contrast against the dark, textured wall. That contrast in value and color intensifies the feeling of light and establishes the mood of the painting.

Trattoria
29½" × 21½"
(75cm × 55cm)

Step 4: Establish Closer Hills

To paint the closer hills, use a no. 12 round brush and add a touch of Cerulean Blue to the same wash as used in step three. Paint these hills in two layers, letting the paint dry in between. These transparent layers, one on top of the other, create just enough contrast so the hills are slightly separate in value.

Step 5: Add Foreground Base Color

Paint the foreground a darker mixture of Yellow Ochre, Cerulean Blue and Quinacridone Rose. Add a little Sepia to darken the value of the colors. Apply this wash with a no. 8 round brush, letting the colors mix and mingle using a wet-in-wet technique. Notice how the Quinacridone Rose seems to rise to the surface and gives the illusion of light reflecting off the sky.

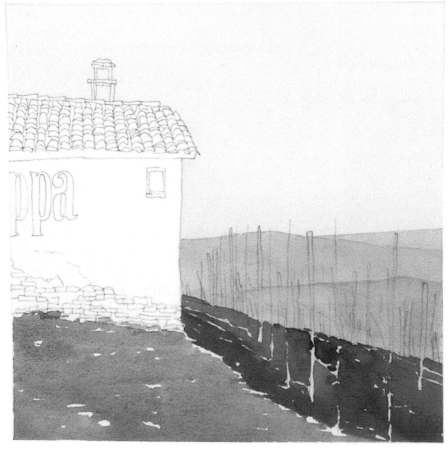

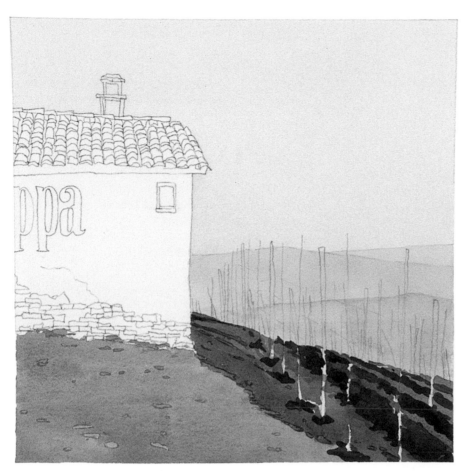

Step 6: Paint Foreground Midtones

Quinacridone Rose and Sepia mixed together make a good color for the rows of dirt. Use a no. 8 round brush and apply this color. Mix Cerulean Blue and Yellow Ochre and fill in the "skips" to give the suggestion of texture in the grass with a no. 6 round brush.

Step 7: Work on the Building

Burnt Sienna, Cerulean Blue, Quinacridone Rose and Winsor Red mixed together make a good color for the building. Apply this wash with a no. 12 round brush. Use more Cerulean Blue toward the lower part of the wall to give the impression of age. As the wash starts to soak into the paper, sprinkle table salt on the damp paint. Let it dry completely before removing the salt.

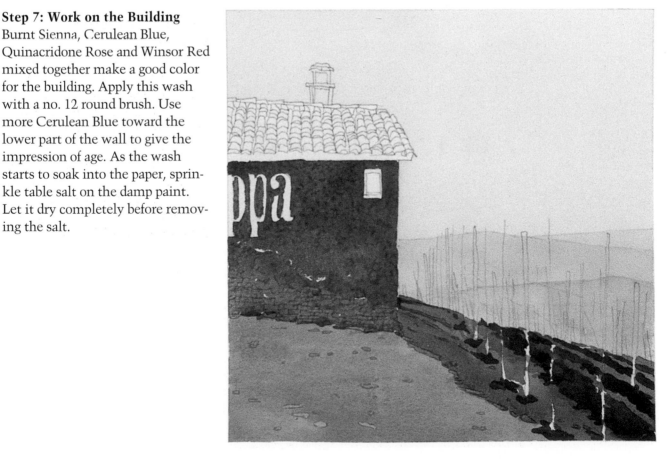

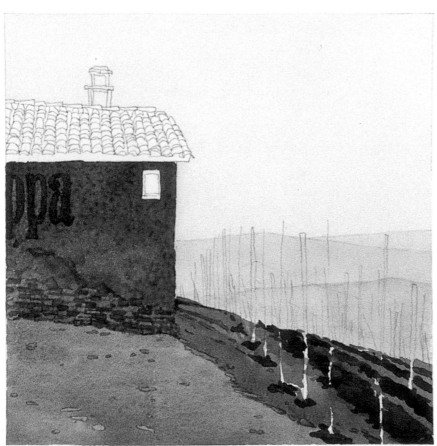

Step 8: Lettering and Bricks

Use the same wash as in step seven, but with extra Winsor Red added to it, and paint the lettering with a no. 8 round brush. Sprinkle salt as the paint starts to dry. Do the same with the bricks. Get variety in color and value by varying the amount of mixed colors, making some bricks more bluish and some more reddish. Let it dry and remove the salt.

Step 9: Paint Roof Tiles

Mix a light, medium and dark color for the roof tiles combining Indian Red, Burnt Sienna, Quinacridone Rose and Cerulean Blue. Use a no. 6 round brush and paint the tiles, skipping around so each tile has a chance to dry before adjacent tiles are painted. Paint the window surround and chimney in the same fashion. Paint the inside of the window with Sepia.

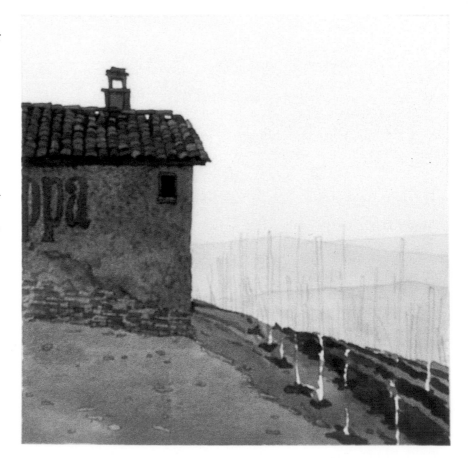

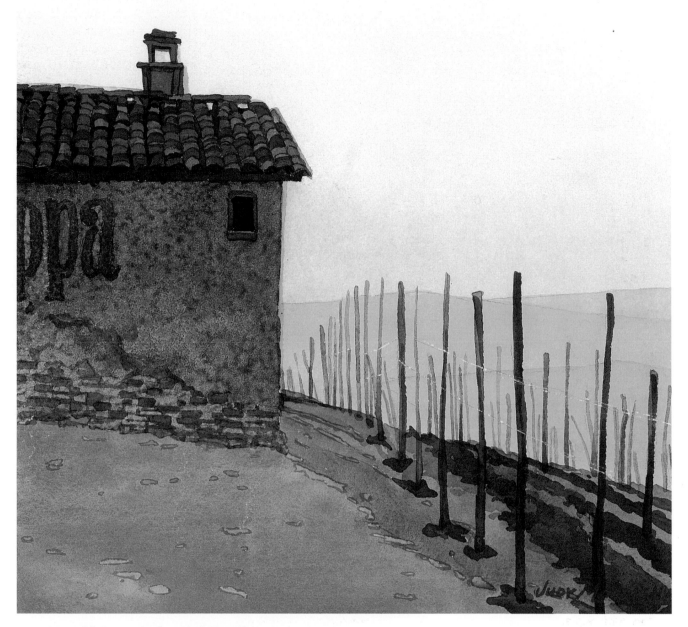

Step 10: Add Grape Stakes and Details
Mix Cerulean Blue, Yellow Ochre and Quinacridone Rose into light, medium and dark grays. Use a no. 6 round brush and paint the grape stakes in the distance the palest gray. As they move closer to the foreground, increase the value and intensity of the of the gray. The closest grape stakes should have the most color and detail. Use a sharp craft knife to draw a few wires between the grape stakes. Soften the edge of the building against the sky by painting a pale line of Quinacridone Rose where the building meets the sky. You have painted haze!

Franco's Back Yard
10" × 10" (25cm × 25cm)

Painting the Light From the Sky

Every painter knows the importance of the interaction between the permanent features of the land and the ever-changing sky. What happens in the sky influences what is put on all paper or canvas. The sky determines not only the flow of light, but the colors, textures and values that set the mood of a painting. The variety is practically endless!

Bright, Sunny Skies

Shadows play a major role in conveying the impression of bright sunlight. The more contrast there is between the shadow and the object that causes the shadow, the more intense the sunlight seems. While bright, sunny skies produce strong shadows, they also wash out color. It is the combination of strong shadows and washed-out color that is typical of what happens on bright, sunny days.

On a Sunny, Bright Day
Shadows are intensified and colors are washed out in bright sunshine. The shadow that defines the shape of the pot and the cast shadow are severe. Notice, in the cast shadow, how the detail of the branch of olives is simplified into a single shape. The eye sees contrast more than color.

Pot From Provence I
9" × 12" (23cm × 30cm)

Overcast Skies

Shadows are diminished or even eliminated under overcast skies, and color becomes the focus in the atmosphere. On a completely overcast day the natural light levels are relatively low, and color intensifies and becomes brighter.

On an Overcast Day
The colors in this demonstration painting are rich and the shadows are practically eliminated. Underpainting with Burnt Sienna established a richness of color that is typically found on an overcast day.

Pot From Provence II
9" × 9" (23cm × 23cm)

Cool Underpainting

Warm Underpainting

Combination Underpainting

Underpaint for Rich Color
Use the technique of underpainting to achieve really rich color when you are painting objects under an overcast sky. Use a wash of Cerulean Blue and French Ultramarine if the objects you are painting are cool in color. Use a wash of Burnt Sienna if the objects are warm in color. If you have both warm and cool colors in the same composition, paint the areas accordingly.

Observing Clouds

Clouds move and change as fast or faster than shadows. You have to be quick! You need to have a plan and attack the changing problem with assurance. A good teacher once talked about painting ocean waves. He suggested painting not what we see but what we know. He challenged his students to learn the movement of the waves by watching what they do for at least a half hour. Then paint. That advice works for clouds as well. Watch the clouds. Learn how they move. Observe the colors and how they absorb reflected color from adjacent clouds, the sky and the ground below. Close observation and practice will teach you to paint clouds.

Pretty Pink Clouds

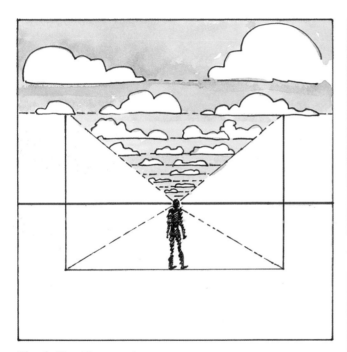

Clouds Have Perspective
Clouds take many forms and shapes, but no matter what kind of clouds they are, the laws of perspective apply. Cloud shapes become smaller as they recede. Clouds also have flat bottoms, similar to that of a ceiling. Using the correct perspective when you paint clouds increases the illusion of space.

Dark, Dramatic Clouds

Light, Luminous Clouds

Exercise Two
Painting Clouds

Blue skies and billowy clouds over this tranquil scene in Holland offer the perfect opportunity to paint clouds and shadows at the same time! Each enhances the other and a "fresh-air" mood results when the best of both are combined.

Paper
Arches 300-lb. (640gsm) cold-press
 watercolor paper

Palette
Phthalo Blue
French Ultramarine
Cobalt Turquoise
Permanent Alizarin Crimson
Winsor Green (Blue Shade)
Yellow Ochre
Indian Red
Cerulean Blue
Winsor Red
Sepia

Brushes
Round: no. 5, no. 6, no. 8, no. 10
 and no. 12

Other
Masking tape
No. 2 pencil
Cotton swabs

Step 1: Pencil Sketch
Use a no. 2 pencil and reproduce this image on your watercolor paper. You do not need to draw in the cloud shapes unless you feel you need very light guidelines to make sure you maintain the correct perspective.

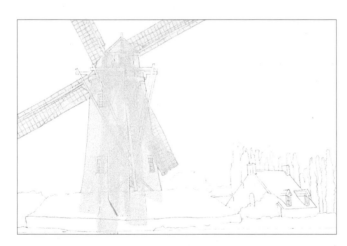

Step 2: Mask the Windmill
Protect the shape of the windmill by covering it with masking tape. This allows you more freedom when you paint the sky. Do not cover the edges of the trees with masking tape. A softer edge between the trees and the sky is a better choice. You do not need to cover the wood "wings" since they will be painted a dark color.

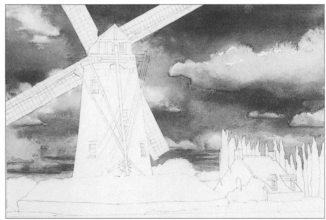

Step 3: Paint the Sky
Use a no. 12 round brush and paint the sky using a wet-in-wet technique. Mix a big, juicy wash with Phthalo Blue, French Ultramarine and Cobalt Turquoise and paint around the cloud shapes. Let the blues mix on the paper, blotting with a paper towel to soften the edges of the cloud shapes. Add a little Permanent Alizarin Crimson and lots of water to the blues to paint the flat bottoms of the clouds. As the paint dries, adjust edges by blotting with a dry brush or a paper towel. Take advantage of blooms to enhance the cloud shapes. If the colors do not dry exactly as you want them to, you can coax some of the color off with a cotton swab. Let the sky dry completely and remove the tape.

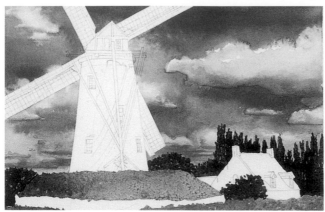

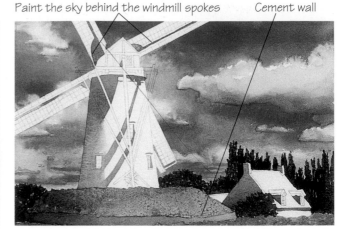

Paint the sky behind the windmill spokes Cement wall

Step 4: Paint the Greens

Mix Winsor Green and Yellow Ochre for the grass on the mound below the windmill. Since the light source for this painting comes from the right side, use more water and less pigment on that side of the mound, and more pigment and less water on the darker left side. Combine Winsor Green (Blue Shade) and Indian Red for a duller green for the foliage in the background and the bush that is in the shade at the side of the house. Dilute this duller green in the extreme foreground to direct attention to the windmill. Use a no. 10 round brush and paint the greens in the appropriate places. Sprinkle salt for a texture that mimics foliage. Remember to let adjacent green areas dry so colors do not mingle. Let dry and remove the salt.

Step 5: Add Shadows

Mix Cerulean Blue, Indian Red and Yellow Ochre to make a gray. Use a no. 8 round brush and paint the shadow side of the house, side of the dormers, side of the chimneys and the shadow under the front eaves. Use a no. 12 round brush and paint the shadow on the windmill. Add a touch of Cobalt Turquoise to the left side of the shadow—reflected color from the sky! Take advantage of the time it takes for the shadows to dry and mix blues that match the sky behind the spokes of the windmill. Fill in the appropriate colors with the no. 8 brush. Paint the cement wall that surrounds the mound going from light gray nearest the light source to a dark gray on the left side.

Step 6: Paint the Roof and Sails

Use your no. 8 round brush and paint the roof of the house Indian Red. Use the same brush and mix Winsor Red into the Indian Red for a more intense color. Paint the sails of the windmill and the window frames of the house with this brighter red. Mix Winsor Red, Winsor Green (Blue Shade) and Sepia to make a very dark brown. Use the no. 8 brush and fill in the top of the windmill and the guide timbers.

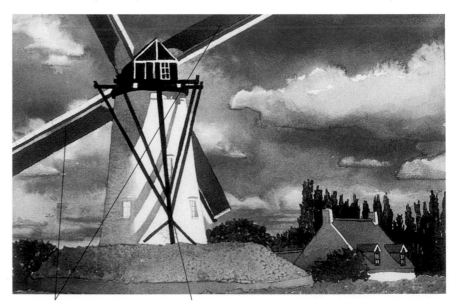

Windmill sails Guide timbers

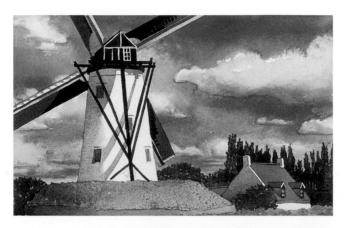

Step 7: More Shadows

Mix a gray, again using Cerulean Blue, Indian Red and Yellow Ochre. Soften the white sections of the windmill and house, and create shadows on the sails by brushing on a pale wash of gray using a no. 6 round brush. Paint the shadows around the windows and soften the white beams on the top of the windmill with a light wash of the same gray. Mix Winsor Red, Permanent Alizarin Crimson and Sepia to make a dark red for the shadow color on the red sails. Use the no. 6 brush to paint the red shadows.

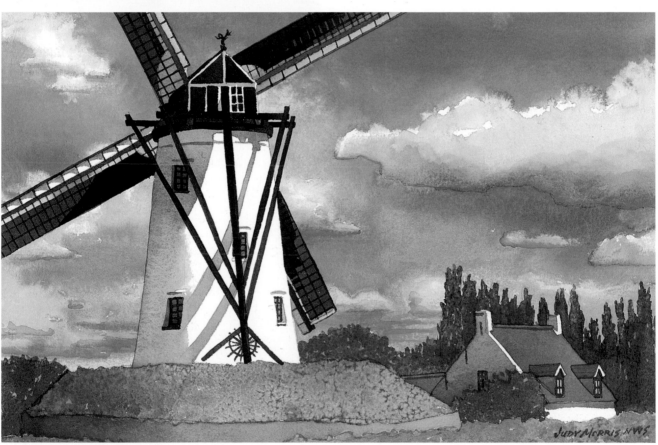

Step 8: Finish the Details

The finishing details require a round brush, no. 5 or smaller. Mix French Ultramarine and Sepia to make a very dark brown. Paint the grid details in the sails, the weather vane, the grids in the windows, the direction wheel and the window and iron pieces on the side of the house. Done!

Red, White, & Blue...in Dutch
10" × 15½" (25cm × 39cm)

Painting Rain

When a scene is viewed through raindrops the scene is reduced to drab colors and muted shadows. What shadows you find in a rainstorm occur only under objects because the flat light from the overcast sky is too weak to cast sharp edges. Color is reduced to gray, and distant details are diminished to a blur. A good gray to use is the mixed gray that results by mixing the colors of the Desert Triad: Cerulean Blue, Indian Red and Yellow Ochre. The dulled reds, blues and yellows effectively mimic the atmosphere of a rainstorm.

There is a reflective quality in a rainstorm that turns flat surfaces into puddles that act like little mirrors. Including puddles in a "rain painting" adds an element of contrast and makes the painting more interesting.

"Draw" the Rain
Use the end of a 1-inch (25mm) flat aquarelle brush with its sharp, diagonal tip to draw lines into a wet watercolor wash. The pigment collects in the lines and they become darker than the rest of the wash. The parallel lines look like rain!

Scratch the Rain
Use a sharp craft knife with a ruler as a guide to scratch lines across the surface of a dry painting. Little bits of the white paper are revealed and the scratched lines give the impression of light reflecting off streaks of rain.

Reflections on Water

Light bounces off water on clear, sunny days and on dark, dreary days as well. The water acts like a mirror and reflects, and even intensifies, the available light. Paintings of rain-drenched subjects quite often sparkle because light is caught in the reflections. Painting accurate reflections isn't difficult but it does require following a few simple guidelines.

Perfectly still water is as smooth as glass and reflects like a mirror. The images are very close to exact replicas of the objects being reflected.

When the surface becomes disturbed by wind or moving objects in the water, the reflection is broken up into many little "mirrors" and the image is broken up as well. The reflection echoes the shape of the object above it, but the image is broken instead of exact.

When there is a lot of movement in the water there is no reflection at all. The water picks up little bits and pieces that do not fit together to create a definite image.

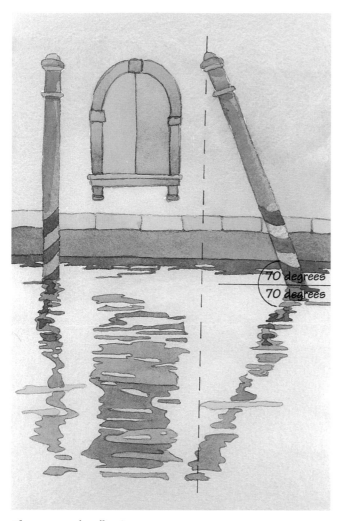

70 degrees
70 degrees

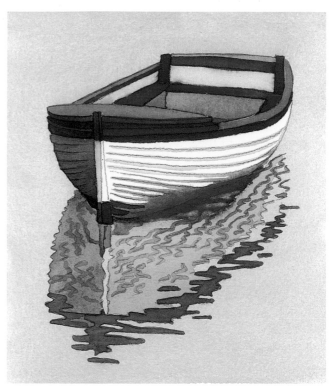

Color and Value of Reflections

Even in the smoothest water, where the shape of the reflection is almost identical to the object it reflects, the value and color of the reflection are not the same as those of the object itself. Colors in the reflection are less intense. See how the bright red on the boat is less intense in the reflection. The white of the boat is slightly grayed in the reflection, and the dark gray on the left side of the boat is not quite so dark in the reflection. An easy rule to remember is "lights reflect darker, and darks reflect lighter."

Placement of Reflections

A reflection is directly below the object being reflected. If the object is at an angle, like the pole on the right, the reflection must be painted at the same angle, only reversed. Notice that the top of the leaning pole and its reflection match up on a vertical line.

Exercise Three
Painting Reflections

Paintings of rain can be most effective when the light reflected in the puddles caused by the rain is included in the painting. These chairs, found in Brighton, England, would have had marvelous shadows on a sunny day. But it was raining. Change the inspiration and mood of the painting to fit the weather!

Paper
Arches 300-lb (640gsm) cold-press
 watercolor paper

Palette
Indian Red
Cerulean Blue
Yellow Ochre
Sepia
Winsor Green (Blue Shade)
Winsor Red
French Ultramarine
Cobalt Turquoise

Brushes
Round: no. 6, no. 10 and no. 12

Other
No. 2 pencil
Staedtler Karat watercolor pencils,
 no. 2 (red) and no. 35 (blue)

Step 1: Pencil Sketch
Draw this image on your watercolor paper with your no. 2 pencil and the watercolor pencils. When a drawing is complicated it is sometimes difficult to distinguish between the shapes that are reflected lights and the shapes that are reflected colors. Using a colored watercolor pencil makes it easier to designate which is which and there is less confusion when it comes time to paint. (Using colored pencils works really well for flowers and foliage too!)

Step 2: Paint the Sky and Sea
Mix Indian Red and Cerulean Blue to make a grayish pink. Use a no. 12 round brush and apply that mixture to the sky area. Let it dry. Using the same brush, add more Cerulean Blue to the wash and paint the water. Paint right over the railing. Later you will paint it a dark shade of green and the color of the ocean will be obscured.

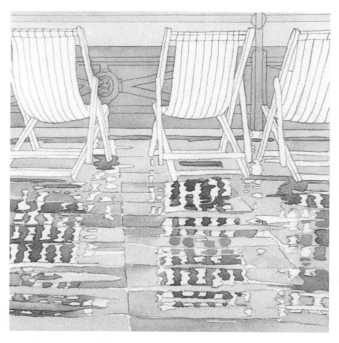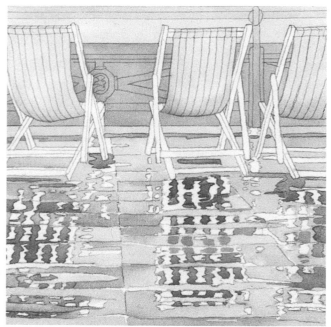

Step 3: Paint the Concrete Deck

Mix Indian Red, Cerulean Blue and Yellow Ochre for a variety of midtone grays. Paint the concrete deck with a no. 10 round brush. As you touch the edge of a shape drawn with a colored watercolor pencil, the color from the pencil line flows into your gray wash. This adds to the reflective feeling of rain water on the deck.

Step 4: Establish the Form of the Chairs

Use the same mixed gray from step three to add form to the chairs. With a no. 10 round brush, apply a yellow-gray to the top of the chairs. Gradually add more Cerulean Blue so the bottoms of the chairs are a bluish gray.

Step 5: Add Chair Frames and Railing

Mix Indian Red, Cerulean Blue and Yellow Ochre into a big puddle of gray on your palette. Use a no. 6 round brush and paint the shadows at the top and back of the chairs. Add Sepia to part of the gray mixture and paint the chair frames. Use a no. 6, or smaller, round brush for better control when painting straight lines. Mix Winsor Green (Blue Shade) into some of the gray and paint the railing.

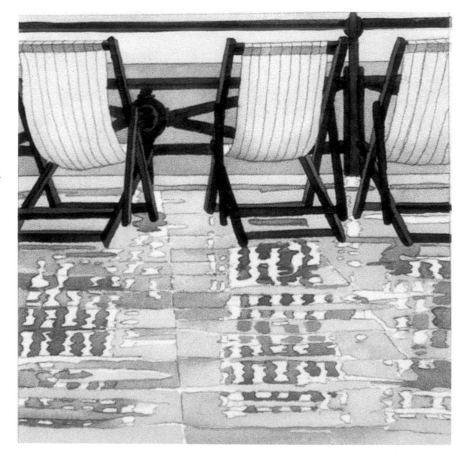

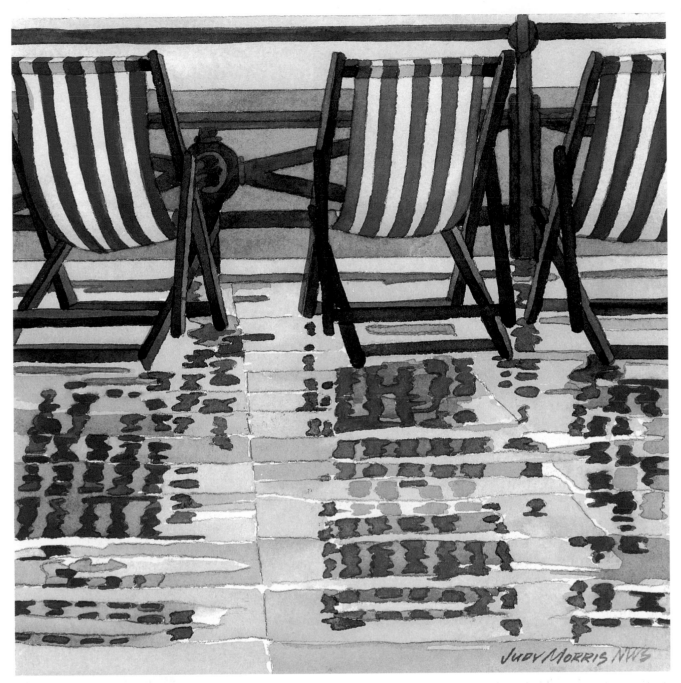

Chairs at Brighton
9½" × 9½" (24cm × 24cm)

Step 6: Stripes and Reflections

A gray and rainy atmosphere has been established in steps two through five. Now it is time to add the color overcast skies accentuate and the contrasts of reflected light. Use a no. 6 round brush and paint Winsor Red almost full strength for the stripes on the red chairs, and French Ultramarine mixed with Cobalt Turquoise for the stripes on the blue chair. The color reflected in the puddles will not be as bright as the stripes. Tone down Winsor Red and the blue mixture by adding a little Indian Red to both. Use your no. 6 brush and paint the areas of reflected color. Use Sepia, dulled a bit with Indian Red, and fill in the shapes of the reflected chair frame. Soften the contrast between the railing and the ocean by applying a glaze of Cerulean Blue mixed with Indian Red on the ocean. This final adjustment completes the painting.

Light and Snow

Snow, like rain and water, is colorless. Snow, also like rain and water, reflects light and absorbs color and value from objects around it. During a snowstorm, light from the sun is obscured and color is reduced to almost black and white. When the sun comes out and the sky clears, color returns.

The best color for painting snow, however, is not a color at all: It is the white of the white watercolor paper! Areas of paper left unpainted represent the purest white in a snow scene. Light washes of color and deeper colors painted in shadows, soft or crisp depending on the weather conditions, define forms in a snow painting. The strength of the sunlight, the color reflected from the sky and the color from objects in the environment determine what colors to use in the shadows.

Mostly Value
This photograph of a rose bush in the snow shows how a blanket of snow seems to reduce color to mostly black and white and shades of gray.

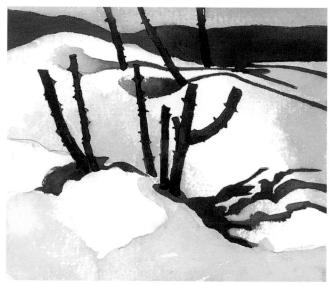

Subtle Color
A quick watercolor sketch of the same rose bush demonstrates how adding subtle color in the shadows makes the scene more appealing. Shadows painted by mixing Quinacridone Rose and Gold, Phthalo Blue and Sepia are more lively than shadows that are gray.

Exercise Four
Painting Chairs in the Snow

Snow on these Adirondack chairs creates a contrast that cannot be ignored. The late afternoon winter sun, barely visible through a haze of clouds, casts a warm glow that seems to bounce everywhere! It presents the perfect opportunity to catch light and color in a snow scene.

Paper
Arches 300-lb. (640gsm) cold-press watercolor paper

Palette
Quinacridone Rose
Quinacridone Gold
Phthalo Blue
Sepia

Brushes
Round: no. 6, no. 8 and no. 12

Other
No. 2 pencil

Step 1: Pencil Sketch
Use a no. 2 pencil to draw this image on a piece of watercolor paper.

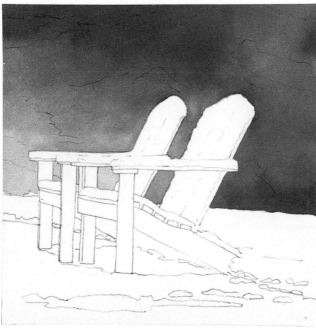

Step 2: Underpaint the Background
Use a no. 12 round brush and underpaint the background with Quinacridone Rose, Quinacridone Gold and Phthalo Blue in a random pattern. These colors in the underpainting will become the "light" in a dark background.

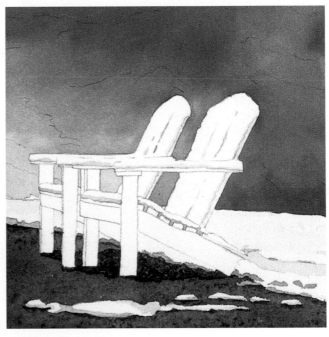

Step 3: Paint the Snow
Use a no. 8 round brush and paint the shadows in the snow pale tints of Phthalo Blue, Quinacridone Gold and Quinacridone Rose. Leave the white of the paper unpainted for the areas of pure white snow. Mix the same three colors and add Sepia to the mixture for the color of the ground. Use your no. 8 brush and paint the ground and, as the paint is starting to soak into the paper, sprinkle table salt on the damp wash. Let it dry completely. Remove the salt. Use the no. 8 brush and slightly darken the area under the chairs and below the snow in the foreground with a wash of Sepia.

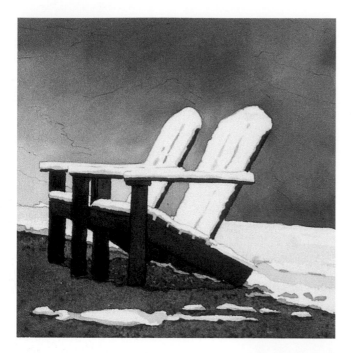

Step 4: Paint the Chairs
Use a no. 6 round brush and paint the chairs Sepia with just a hint of Phthalo Blue added. Change values slightly between planes to give form to the chairs.

Step 5: Finish the Background
Subtle shapes of trees and bushes emerge from the background when a gray made from mixing Phthalo Blue, Sepia, Quinacridone Rose and Quinacridone Gold is applied. Use a no. 8 round brush and define the foliage by building up thin layers of paint, letting one layer dry before the next is applied. The color from the underpainting becomes the snow on the trees and bushes. Use a no. 6 round brush and apply a touch of Quinacridone Rose to the snow under the chairs and in between the slats of the chair seats. It's a perfect finish!

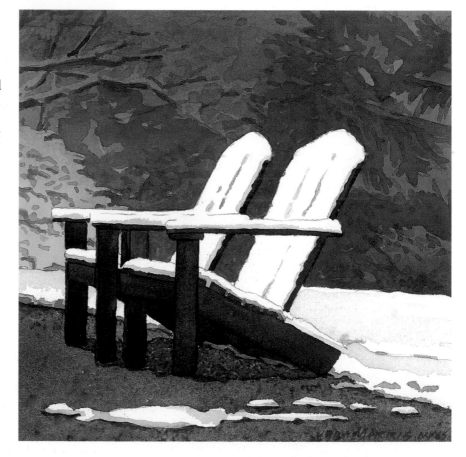

Dusk Duet
9" × 9" (23cm × 23cm)

Interior Lighting

There are as many painting possibilities inside as there are outside. (There will never be enough time!) The feeling of light, the atmosphere, the mood and the subjects change, but paintings of interiors remain as fascinating as outdoor paintings. People are often included in interior paintings. However, if people are absent in interior paintings, their presence will still be evident. There may be an open book, a window curtain, a piece of furniture, beautiful dishes or even a sink full of dirty dishes. The human touch is obvious in every interior painting.

The kind and quality of light in interior paintings is as varied as is found outdoors. High-key indoor paintings summon light, airy, cheerful and delicate moods, while low-key indoor paintings suggest dreariness, mysteriousness and a sense of melancholy. Light coming from an open window or door brings in cool colors with bluish undertones. Light coming from an interior source, such as a candle, a lamp or the glow from a fire in the fireplace, casts a warmer but dimmer glow.

Shadows

The cool, clear light falling on this table came from the east. When strong sunlight, such as in this example, shines into an interior, the biggest bonus is the shadow! This shadow, cast from light falling on the flowers, dishes and silver, is the motive for the painting! Capturing the warm glow in the shadow that reflects the brownish, more neutral colors from the interior of the room makes the shadow even more compelling.

After the Tea
18" × 24" (46cm × 61cm)

Views

A view through a window or door, with the viewer inside looking out, offers the opportunity to paint an intriguing double image. In this case, the window provides not only a frame for what is happening outside, but the patterns of light and dark suggest sunlight filtering through the curtain creating a wistful mood. Changes in this scene would occur from day to day, even hour by hour, as the light source outside changes. The mood that light evokes changes as quickly as the light itself.

Country Club Drive
24" × 18" (61cm × 46cm)

Exercise Five
Painting Lamp Light

When there is a single light source, a sense of illumination is best achieved when nearly monochromatic (tints and shades of one color) or analogous (tints and shades of three adjacent colors on the color wheel) color schemes are used. It is important that all the objects in the painting have the same undertone because they are all bathed in the same light. Strong value contrasts accentuate a single light source by directing the eye to the light source.

This small lamp shines a wonderful golden glow on the books and small plant. The subtle reflections on the table surface and highlights on the edge of the table make the glow from the lamp convincing.

Paper
Arches 300-lb. (640gsm) cold-press
 watercolor paper

Palette
Cadmium Yellow
Indian Red
Cerulean Blue
Sepia
Burnt Sienna
Carbazole Violet
Winsor Green (Blue Shade)
Winsor Red

Brushes
Flat: 1-inch (25mm)
Round: no. 6, no. 8 and no. 12

Other
No. 2 pencil

Step 1: Pencil Sketch

Use a no. 2 pencil and reproduce this image on your watercolor paper.

Step 2: Establish Illumination

Use a 1-inch (25mm) flat (it covers more area than a round brush) and apply a pale wash of Cadmium Yellow over everything except the books (a Cadmium Yellow wash on the books would lower the intensity of the Winsor Red they will eventually be painted). This wash becomes the light created by the lamp. Let it dry. Use the same brush and apply an Indian Red/Cerulean Blue wash, starting at the top of the paper and stopping when you get to the semicircle line that defines the arc of light. Before this wash dries, use a no. 12 round brush charged with clear water and run a line of clear water at the bottom edge of the wash. The edge of the wash will soften and form a diffused edge along the arc of light.

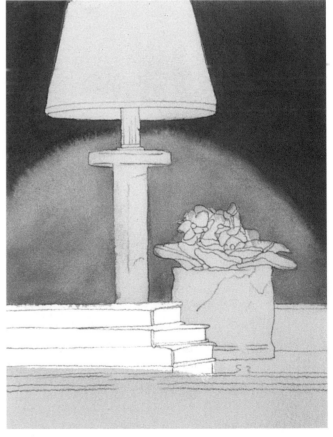

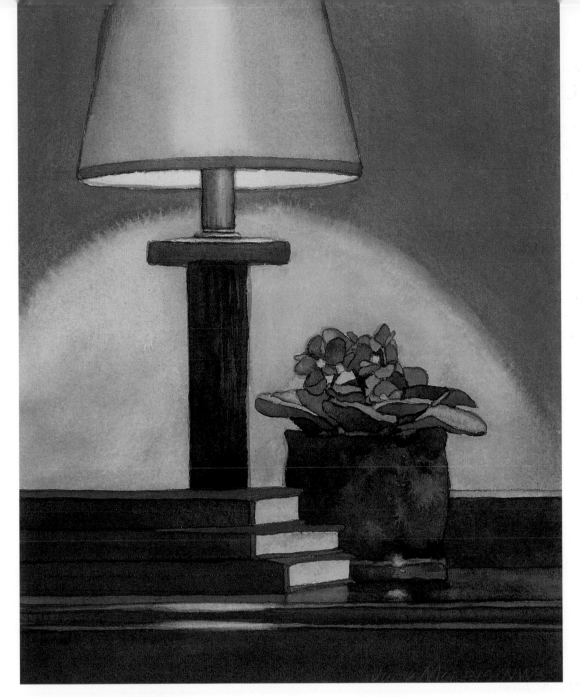

Step 3: Finish the Painting

Mix Sepia with Cerulean Blue and Burnt Sienna to paint the lamp base, flower container and table top with a no. 8 round brush. Mix Carbazole Violet and Burnt Sienna and paint the flowers with a no. 6 round brush. Use this same brush to paint the leaves with a mix of Winsor Green (Blue Shade) and Burnt Sienna.

Use pure Winsor Red and paint the parts of the books in direct light. Mix Indian Red and Burnt Sienna with Winsor Red to paint the parts of the books in shadow.

Use the brush-lift technique to make the highlights on the table edge. Use your no. 6 brush and run a line of Winsor Red around the lamp, the edge of the violet container and under the lamp shade to soften edges into the background.

My Violet
9½" × 7½" (24cm × 19cm)

Exercise Six
Painting Candlelight

Objects farthest away from a candle flame receive the least amount of light. By placing a glass candleholder in the still life, more light is moved to the lower portion of the composition. Subtle reflections from the flame bounce off the top and edge of the table.

Paper
Arches 300-lb. (640gsm) cold-press
 watercolor paper

Palette
Cadmium Yellow
Indian Red
Cerulean Blue
Sepia
Yellow Ochre
Winsor Red

Brushes
Flat: 1-inch (25mm)
Round: no. 6, no. 8 and no. 12

Other
No. 2 pencil

Step 1: Pencil Sketch
Use a no. 2 pencil and draw this image on your watercolor paper.

Step 2: Establish Illumination
Use a 1-inch (25mm) flat and apply a pale wash of Cadmium Yellow over the background, book and tabletop. As the wash begins to dry, use a paper towel to blot an area the size of a quarter where the flame is the whitest. Let the wash dry completely. Use a no. 12 round brush charged with clear water, and paint a circle of water around the flame. As the water begins to soak into the paper, paint a mixture of Indian Red and Cerulean Blue on the wall, circling the glow of the candle. Add more pigment as you paint away from the candle's tip. A smooth, golden glow radiates from the light of the candle.

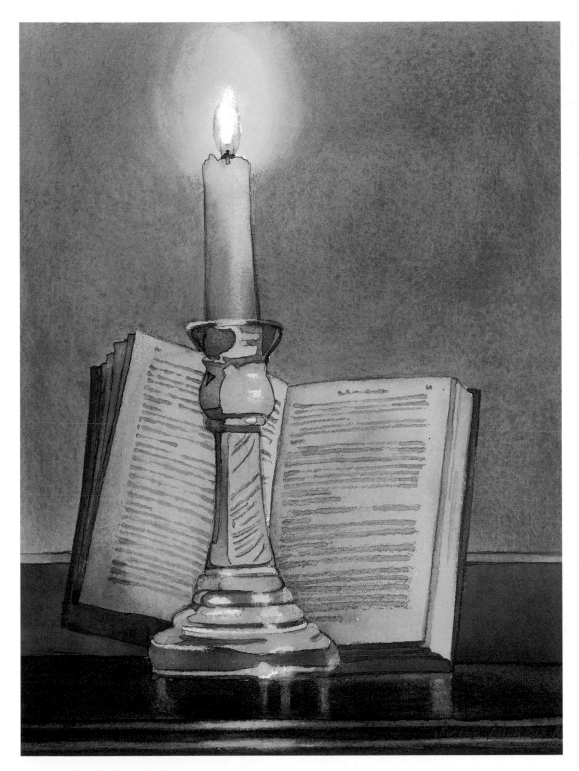

Step 3: Finish the Painting

Mix Sepia, Cerulean Blue and Burnt Sienna and paint the tabletop with a no. 8 round brush. Use this same brush to paint the pages of the book, using a mix of Cerulean Blue, Indian Red and Yellow Ochre. Add Winsor Red to this mix and paint the dark and light areas of the candleholder in variations of those four colors.

Mix Winsor Red, Indian Red and Cerulean Blue and paint the cover of the book. Add the "text" with a concentrated mix of Indian Red and Cerulean Blue.

Paint in the candlewick with Sepia using a no. 6 round brush. Use a typewriter eraser to gently coax the shine on the edge and top of the table and on the candleholder. Erase any pencil marks in the flame.

Pages 24 & 25
9½" × 7½"
(24cm × 19cm)

Step 5: Paint the Iris Leaves

Use the same colors and follow the same techniques you used in step four to paint the iris leaves.

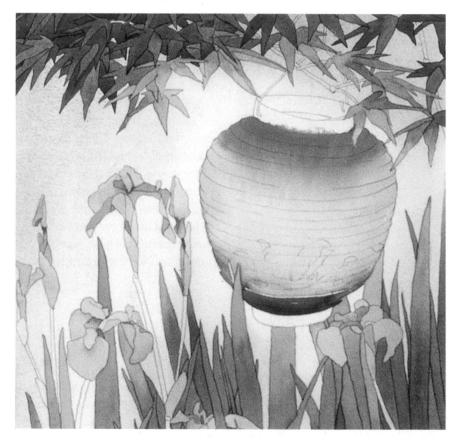

Step 6: Paint the Iris Blossoms

Use a no. 8 round brush and paint the water iris with tints of Cadmium Yellow. Add clear water for the lighter petals and add more pigment for the darker petals. Add a touch of Winsor Red for color depth in the centers and on some of the edges of the petals. Mix Winsor Green (Blue Shade) with Cadmium Yellow and paint the buds with the no. 8 brush.

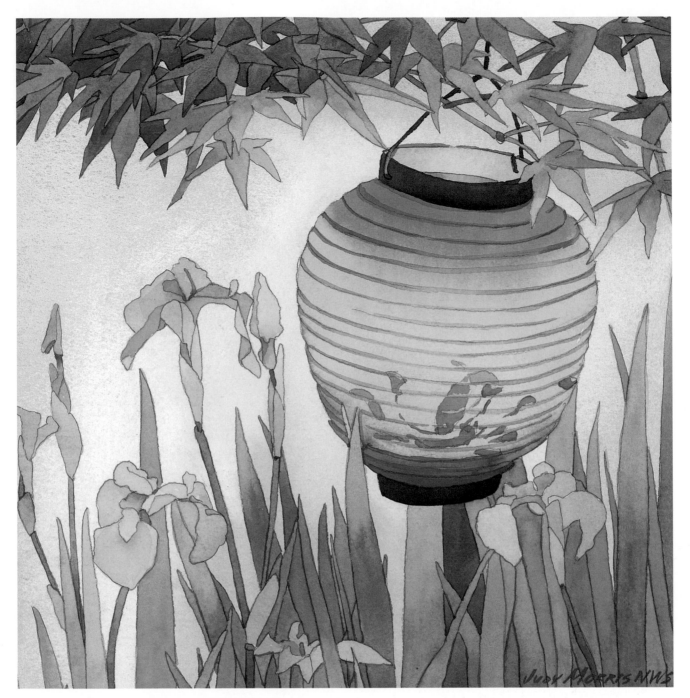

Step 7: Finish the Lantern and Stems

Use a no. 8 round brush and paint the inside of the top of the lantern Cadmium Yellow and Cadmium Yellow mixed with Winsor Red. Use the same brush and paint the "ribs" of the lantern with a mixture of Cadmium Yellow and Winsor Red. Paint the design on the lantern with the same brush and colors. Mix Winsor Red, Burnt Sienna and French Ultramarine for a dark color and paint the top and bottom of the lantern.

Bring some warmth to the top of the composition by painting the stems in the trees with Burnt Sienna using a no. 6 round brush. Add French Ultramarine to the Burnt Sienna and paint the wire the lantern is hanging from. Mix Burnt Sienna, Winsor Green (Blue Shade) and French Ultramarine and paint the iris stems with the same brush.

The last adjustment is to strengthen the design by painting the empty space directly below the lantern a dark green. Mix Winsor Green (Blue Shade), Cerulean Blue and Burnt Sienna to make the correct color and fill in that space with your no. 8 brush. Your lantern glows with soft, interior light!

Patio Spirit
13" × 13"
(33cm × 33cm)

Gallery

I used a limited palette of Cerulean Blue, Indian Red, Yellow Ochre and Morris Black to capture the light I found shining on discarded furniture in Half Moon Bay, California. Using this limited palette allowed me to concentrate on the value differences that created the contrasts needed to paint light. I painted around the white areas of the wicker chair with midtones mixed by combining Cerulean Blue, Indian Red and Yellow Ochre.

Since light reflects in a mirror similarly to light reflecting in water, I used the rule "lights reflect darker, and darks reflect lighter" when I painted the image of the chair in the mirror. I underpainted the reflection of the chair with a mixed gray so there would be no pure white. By doing this, I heightened the feeling of bright light shining on the top of the chair.

The Cerulean Blue sky implies sunlight because on bright, sunny days the sky appears to be the color of Cerulean Blue. I added Morris Black to Indian Red to make a very dark background for a strong contrast against the white and light grays of the chair. To finish the painting, I exaggerated light by adding highlights on the chair. I used a small, no. 6 round brush and flat latex wall paint, mixed to exactly match the color of 300-lb. (640gsm) Arches cold-press watercolor paper, and painted the "white spots" that represent sunlight falling across the texture of the wicker.

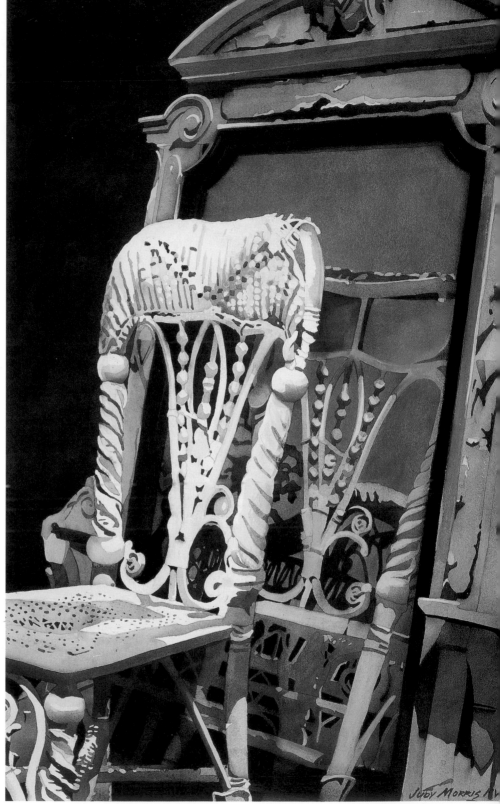

Junkyard Jewels
28" × 18"
(71cm × 46cm)

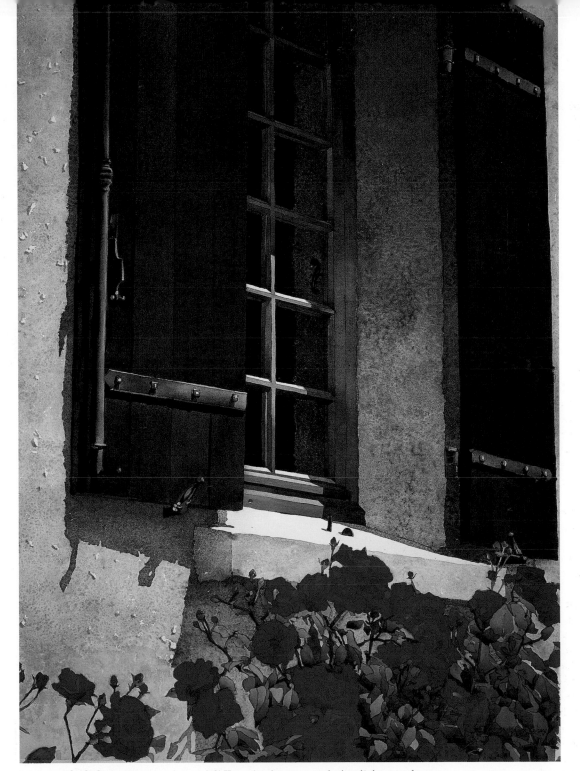

It's true. The light in Provence is special! Knowing how to catch that light transforms an ordinary subject into something extraordinary. Leaving the white of the paper on the window ledge brings the most light to that area. Pale shapes on the window pane echo the feeling of bright sunlight.

The shadow cast from the shutter and the shutter hardware repeat the presence of a strong light source. Red roses under the window gave me the opportunity to paint reflected light by exaggerating red tones in the shadows. Notice the presence of reflected light, especially on the top edges of the shadows.

I sprinkled kosher salt over the surface of the shadow wash. Before the wash dried I fused in pure Winsor Red by touching the surface of the paper between the grains of salt with the tip of a no. 12 round brush charged with red paint. I was careful not to move the grains of salt because that would have interrupted the action of the separating pigments.

Des Roses En Provence
50" × 38"
(127cm × 97cm)

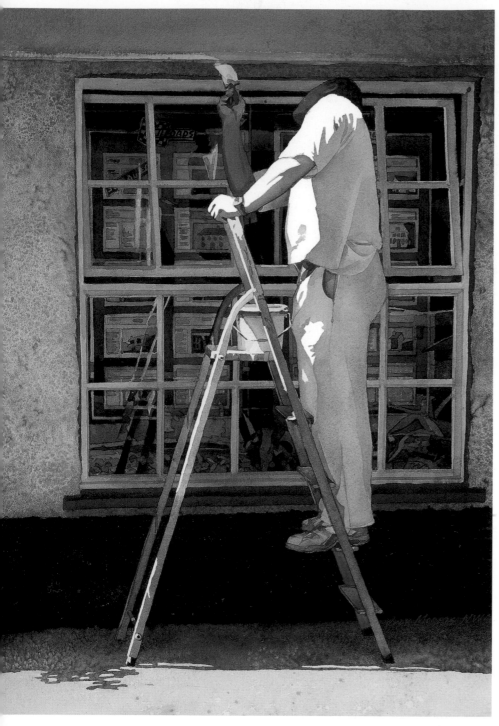

I noticed this man in Topsham, England, not because he was painting the building but because sunlight accentuated the white of his clothes against the dark background of the window display. On an overcast day I might not have found this painting because the contrast would not have been so striking. I used underpainting to emphasize bright light. When my pencil drawing was complete I painted a liquid mask over the areas that would remain pure white.

When the mask dried I covered the entire surface of the paper with a gray wash made by mixing Cerulean Blue, Indian Red and Yellow Ochre. I continued the painting process, and when I felt the painting was finished I removed the mask. I softened harsh edges created by using a liquid mask by painting a thin line of Quinacridone Rose along the edges with a small, no. 6 round brush. The reserved white shapes of the shirt, arm and hand and paint bucket work together to create a strong center of interest that is drenched in sunlight.

But I Don't Paint People
28" × 21" (74cm × 53cm)

La Boulangerie
29" × 21"
(74cm × 53cm)

One spot of sunlight gives life to this scene I found in Lacoste, France. The lack of direct light in the rest of the painting heightens a mood of elegant quietness that the absence of light creates. I used cool colors, all mixed with varying amounts of Cerulean Blue, Permanent Alizarin Crimson and Quinacridone Rose, for the buildings that are not in direct sunlight. Lighter, warmer colors, mixed with Yellow Ochre, were used where sunlight is so clearly evident.

 The contrast between warm colors and cool colors emphasizes the mood and directs attention to the light! The rich blues and violets in the sky are the colors of light as sunset approaches. Subtle reflections of the sky color in the windows and on the surface of the cobblestones that pave the narrow streets maximize the mood.

 I let light draw the viewer into this painting by limiting the warm colors to the small area where sunlight shines on the building. I used the absence of light to lure the viewer down the mysterious path where buildings are so close together that only light at midday could illuminate them.